M000222340

IMAGES
of America

ORMOND
BEACH

We dedicate this book to the memory of the valiant pioneers and courageous individuals who established our community and participated in its growth over the past 235 years and to our youth who will inherit this history and keep its flame burning brightly.

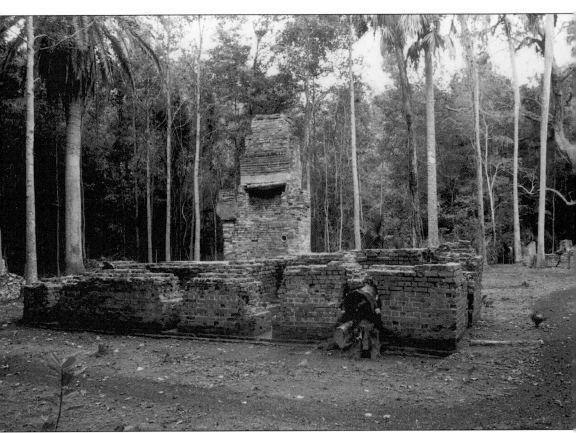

In a hammock of live oaks towering above prehistoric middens and coquina repositories lies the rum-making ruins of the Richard Oswald plantation, built after January 1765 and known, at the time, as the Swamp Settlement. Constructed of coquina and bricks, the structure contains an extant sugarcane boiling house and still built that same year. With fireboxes, iron-flues, and iron-hinges intact, the boiling house was made of hand-formed, burnt-clay bricks laid in the unique British-bonding pattern. Tabby, mortar of sand and burned seashells were used by slaves who also cleared the lands, planted cane, and built a factory that became profitable, according to documents of the day. It remained so until the Revolutionary War. The Trust completed an archaeological survey of the site in 1995, secured a $20,000 grant for a Preservation Plan, which was published July 7, 1999, and successfully petitioned the state to purchase 40 contiguous acres for a park, currently under review for funding (July 29, 1999).

IMAGES

of America

ORMOND
BEACH

The Ormond Beach Historical Trust, Inc.

ARCADIA
PUBLISHING

Copyright © 1999 by the Ormond Beach Historical Trust, Inc.
ISBN 978-0-7385-0257-1

Published by Arcadia Publishing
Charleston, South Carolina

Printed in the United States of America

Library of Congress Catalog Card Number: Applied For

For all general information contact Arcadia Publishing at:
Telephone 843-853-2070
Fax 843-853-0044
E-mail sales@arcadiapublishing.com
For customer service and orders:
Toll-Free 1-888-313-2665

Visit us on the Internet at www.arcadiapublishing.com

Ormond Beach Historical Trust, Inc.

After scoring a stunning success in its 1976 effort to save and restore the former winter home of John D. Rockefeller, the newly created Ormond Beach Historical Trust, Inc., proceeded to rack up steady advances in its ongoing effort to preserve the city's heritage. The Trust persuaded the city commission to establish the Historic Landmark Preservation Board, a citizens' committee with decision-making powers over restoration and demolition of historic structures. The Trust worked with the City of Ormond Beach to have a historic survey conducted that resulted in the nomination of nine structures for inclusion in the National Register of Historic Places (seven of them made the list). The Trust played a leadership role in getting the historic Pilgrim's Rest Primitive Baptist Church building moved onto city property. The Trust conducted a photography contest for pictures of our historic buildings, sponsored essay contests on area history for high school students, held 14 Antique Shows and Sales events and Antiques Symposiums, published a collection of articles about the city's historic homes written by local historian Alice Strickland, and helped establish the city's first historic district.

Add to that list restoring the Ormond Hotel Cupola centerpieced in Fortunato Park, sponsoring the renaming of Riverfront Park to Cassen Park (in honor of a longtime former mayor of the city), salvaging and restoring the MacDonald House, and working with the city to erect a plaque at city hall in memory of another former mayor and outstanding citizen, Joseph Downing Price, and first settler John Andrew Bostrom.

Presently, the Trust's efforts are focused on acquiring and restoring the "Three Chimneys" property on West Granada Boulevard. This was the site of Richard Oswald's 1764 land grant and later Swamp Settlement where sugarcane was grown to manufacture rum in a pre-Industrial Revolution distillery. Membership in the Trust is growing, and the organization has remained faithful to its stated mission: to preserve and protect the historical, cultural, and natural resources of the Ormond Beach area and to promote and develop the use of these resources for the benefit and improvement of the community.

You can help the Trust accomplish its mission by becoming a member. Send your name and address to Ormond Beach Historical Trust, Inc., 38 East Granada Boulevard, Ormond Beach, FL 32176, and we will send you a membership application.

CONTENTS

About the Authors 6

Introduction 7

1. Early American Indians 9

2. Early Plantation Years 17

3. Beachside Settlers 27

4. New Britain Colony and the Birth of Ormond 45

5. McNarys and Other Early Settlers 59

6. Hotel Ormond 67

7. Birthplace of Speed 79

8. Casements and John D. Rockefeller 89

9. Ormond's African Americans 97

10. Mid-20th Century and Today 107

ABOUT THE AUTHORS

Carolyn Barclay, reared in Miami, calls Ormond her home. She holds advanced degrees in education and has co-authored textbooks in the United States, Grenada, and China. Carolyn also initiated a reading program in the Pacific Marshall Islands and was a Peace Corps volunteer/trainer. She has worked in all types of media, with positions ranging from reporter to editor. A published poet, Carolyn was active in little theater productions, has taught Florida history, and is on the Ormond Beach Historical Trust Board.

Ceylon Barclay is the president of the Ormond Beach Historical Trust, Inc. and the president of Dos Culturas en Hermandadas, a philanthropic company working in Nicaragua; the author of four books; and a former college instructor in China and America. He moved to Florida in 1964 and has served on the school board and as president of the chamber of commerce. He was the founder and 25-year president of a company in manufacturing, restaurants, construction, and rum distillation for which he employed 500 workers in seven states and three countries.

Don Bostrom, a native of Ormond Beach, was born here on September 9, 1916. He is a retired executive and the author of *Climb a Tree and Holler*, a book of memories about his youth and his grandfather John Andrew Bostrom, the first settler of Ormond Beach. Don is the treasurer of the Ormond Beach Historical Trust, editor of its quarterly *Newsletter*, and a computer buff who enjoyed helping to author this book.

Gordon Kipp moved to Deland from New York in 1925. He received his B.A. from Stetson University, married, and moved to the Halifax area. Gordon served in the Marine Corps in World War II and Korea, retiring in 1963 as a lieutenant colonel. He has worked for several newspapers, including 20 years with the *Daytona Beach News-Journal*. Gordon serves on the Ormond Beach Environmental Advisory Board and the Volusia County Historic Preservation Board. A past president of the Ormond Beach Historical Trust, Inc., Gordon now serves as its corresponding secretary.

Alice Strickland, a native of Handsworth, Birmingham, England, came to Ormond Beach as a child. She attended Corbin Avenue Elementary, Seabreeze High School, and Mundell's Business School. Alice has been a historical researcher specializing in Volusia County for 70 years and has written several books and numerous articles about Ormond Beach. For 13 years she served as curator of the Fred Dana Marsh Museum in Tomoka State Park. Her honors and tributes would fill this page. She still speaks to clubs and children's groups. Rumor has it a new book is in the offing.

INTRODUCTION

This book is a pictorial history of Ormond Beach, Florida, a catalog of dreams of ordinary people and every-day events straddling 300 years. It links the dots between who we once were, who we are now, and who we might become. As in most dreams, these photographs reflect many attempts and comparatively few successes of visionaries struggling to build new lives on the shifting sands of change confronting all civilizations in all times. You will see handsome Native Americans. Old rum distillery ruins will evoke sounds and smells of sugar plantations. You will feel the moody loneliness, the hopelessness of once-proud slaves torn from Africa and chained to unchosen drudgeries along the Halifax River. You will sense the vast space of the Atlantic rolling in before the first beach-side cottage, Vera Cruz, the tranquillity of the Pilgrims' Church, the roar at the Birthplace of Speed, and the grandeur of the Roaring Twenties. We have tried to whet your appetite to see more of our city, as this brief overview is not a working substitute for a walking tour.

Our story begins in the chaos and insecurity of prehistory—of which we now have only vague hints—from archaeological digs revealing treasures such as a giant, three-toed sloth that roamed Florida 145,000 years ago. Also, middens, or trash heaps, left by Native American inhabitants comprise most of the pre-history sequestered in sugar-sands, probably forever.

Our true story begins when the first Europeans met curious American Indians in 1513, the year Juan Ponce de León, a seafarer with Columbus on his second voyage, sought the Fountain of Youth. The first drawings here are the record of Jacques le Moyne de Morgues's arrival in Florida 51 years after Ponce de León's.

As in all New World settlements, those in Florida were based on economic necessities and political realities. Unique to our region was its ability to raise crops hitherto exclusively raised in the West Indies, where sugar was king. At the time, sugar was a scarce, nearly non-existent commodity, obtained at an enormous price, introduced to, and cultivated in the West Indies since 1550. But those islands were a hotbed of gun-ship diplomacy as ownership ebbed and flowed, an unstable situation that gave birth to Florida sugar-raising. Most sugarcane was raised on 16 plantations stretched along the winding banks of the Matanzas and Halifax Rivers, between St. Augustine and Ponce Inlet. In 1763, after Spain ceded Florida to England at the conclusion of the worldwide conflict known as the Seven Years War, the first settlers soon arrived in the future Ormond Beach. The next year, on July 24, 1764, a 20,000-acre land grant was made by King George III to the Scotsman Richard Oswald. With 50 slaves, Oswald launched his first settlement after 1765 in a Native American-inhabited, subtropical region of coastal Florida.

In the pictures showcased here, we tried to provide both a comprehensive overview and insightful close-ups of broad eras of time, effected by external factors, usually economic needs or wars. Our history traces a story nurtured by Native Americans, who guided black and white men in the ways of tropical crops. We examine sprawling sugar plantations that grew beans, rice (ditches are still evident), onions, garlic, and peas for survival, plus crops of sugar, indigo, and, later, citrus to earn scarce exchange.

Sugarcane, with attendant rum production, continued until the Revolutionary War turned hearts and souls against the British and those Loyalists sympathetic to the English cause. War abruptly ended sugarcane growing in Florida. After that war, Florida was ceded back to Spain as a condition of the Treaty of Paris. During the second Spanish period (1783–1818), scattered attempts were made to re-institute the growing of sugar. For the most part, those attempts failed due to the lack of Spanish financial investments, Native American uprisings, and the First Seminole War of 1817. In 1818, Spain ceded Florida to America, and Floridians were paid $5 million by Washington for their many claims against Spain.

The arrival of mighty sailing ships to the world of transportation brought to Ormond Beach the need for their massive oak-ribs and -backbones and another change. It launched a tree-cutting business that survived for more than half a century. Though few massive live oaks remain, still several measuring over 22 feet in circumference grow in protected public parks. After the heyday of clipper ships, timber harvesting dwindled, and Ormond Beach awaited yet another far-off transportation invention to bring change. This time, horseless carriages shook the sands of Ormond Beach.

The automobile conveyed an unexpected and rapid change when the need to showcase speed brought with it racing, replete with spectators, to our long, flat, white-sand beaches. Within a few years, motorcar racing was firmly established. Tourists followed. Both racing circles and the world-at-large saw cars zipping over sand and people basking in the winter sun on those same beaches, an era and custom still in vogue. What the future will bring is anyone's guess. Perhaps it will be transportation again, since a German manufacturer has a huge dirigible factory planned and local companies make components for the booming auto industry.

The book you hold in your hands was a fantasy; seeing it to fruition was the reality. During the process we've examined thousands of pictures, screened out fuzzy prints, and tried to cover areas of broad interest. This book's charm comes from the preview of things a tourist may see in our city. For the person who knows Ormond Beach, it will recall nostalgic memories of things experienced. For the armchair traveler, it will provide knowledge and intimacy of one of the most beautiful places on earth. As the need to preserve a record of our past becomes more widespread, the consciousness level of all communities is heightened. This is good. But how many ways can the message of times long-gone be shared? Museums, historic ruins, and edifices are interesting, worthy destination points, yet the need to bind them together and carry them into our futures, in a handy way, is the aspiration of this pictorial history.

Credits

We received enthusiastic support and assistance from many people, including,

Gary Buss, professional photographer; Mary Belle Price Coupe, granddaughter of Joseph Price; Tippin Davidson, *Daytona Beach News-Journal*; Ron Edwards, longtime collector of historic memorabilia; Don Gaby, Halifax Historical Society; John Gontner, retired professional photographer; Mary Alice Jordan, member of the pioneer McNary family; Walter Jubinsky, director of Ormond Beach Regional Library; Commissioner Thelma Irvin and Minnie Wade for their research on African-American residents; Audrey Parente, author, writer, journalist; Dick Punnett, author of *Racing on the Rim*; Lewis Slaughter, president of Friends of the Ormond Beach Library, Inc.; and Jill Waterman, New York City professional photographer.

One

EARLY AMERICAN
INDIANS

Two rivers, the Halifax and the Tomoka, in northeast Florida's Volusia County, have played an integral role in the history and development of Ormond Beach. For thousands of years, land along these rivers has been ideal for settlement. The Halifax, actually an estuary, is an arm of the Atlantic that thrusts northward from Ponce de Leon Inlet, meets the mouth of the Tomoka, and splits coastal land into two sections: a long narrow peninsula and the river-bound mainland. At their junction, about 25 miles north of Ponce de Leon Inlet, is Tomoka Basin, a large, shallow body of brackish water where tide meets river. Flowing into it from the southwest is the Tomoka River, a fresh-water stream with a tranquil, tropical beauty, and the setting of present-day Ormond Beach.

The earliest-known inhabitants of these rivers were the Timucua (te-moo-kwa) Indians, whose primitive, blunt-nosed canoes skimmed these waters. The Timucuan threw spears with lightning-quick accuracy to catch abundant fish. They also used weirs, or fish fences, and gathered huge quantities of oysters, discarding shells in piles called middens, some of which survive (pictures included). They were also skilled farmers, raising a wide variety of fruits and vegetables. The Timucua was one of six main tribes living on the Florida peninsula at the time of its discovery by early Spanish and French explorers who left us descriptions of these colorful Indians as "a handsome race of people, tall, well-formed and athletic."

A French artist, Jacques le Moyne de Morgues, came to Florida in 1564 to map and record the seacoast and harbors. His sketches and paintings on the following pages are believed to be the first made of Native Americans in North America. They were engraved for publication in 1590 by Theodore DeBry and provide a vivid depiction of the native culture of that period.

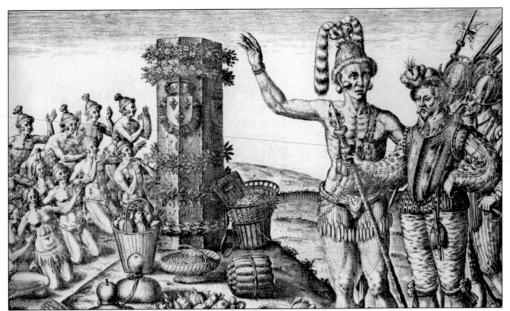

NATIVES WORSHIP A COLUMN. When the French returned in 1564, Commander Laudonniere was assured by Chief Athore that his people bore no enmity. Grave, modest, and with a majestic bearing, the chief stood at least 6 inches taller than the tallest Frenchman. After presents were exchanged, the party canoed to an island where a column, bearing the arms of France, was erected by Ribault. The Indians worshipped it as an idol.

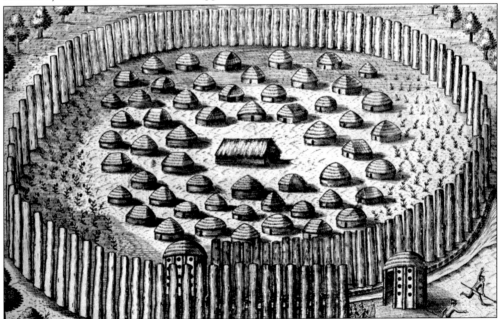

A TYPICAL FORTIFIED VILLAGE. Native Americans built fortified villages near the channels of swift streams. They dug a circular ditch around leveled ground and drove in thick, round pilings placed closely together to a height twice that of a man. The pilings' end would overlap its beginning, making a narrow entrance that admitted no more than two abreast. Nocoroco, the local settlement, probably resembled this picture.

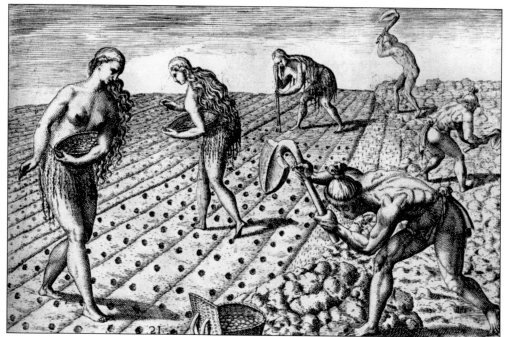

How They Tilled and Planted the Soil. Native Americans tilled soil using an adz, or hoe, of fish cartilage fitted to wooden handles. Since the soil was sandy and light, these tools served well enough for cultivation. After the ground was broken, raked, and leveled, women punched seed-holes while others dropped in bean or maize. The fields were left untended during winter months while Indians sought shelter in inland woods.

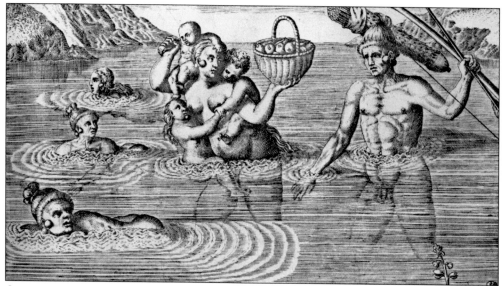

Crossing over to an Island. Many islands dotted shallow rivers of pure water. Natives swam, or, if they had young children, waded to them. This mother took three children, the smallest one on her shoulder, two others clinging to her arms. She also carried provisions in her basket. Men carried bows and arrows. This site appears similar to Tomoka Basin and its tall sand dunes of last century.

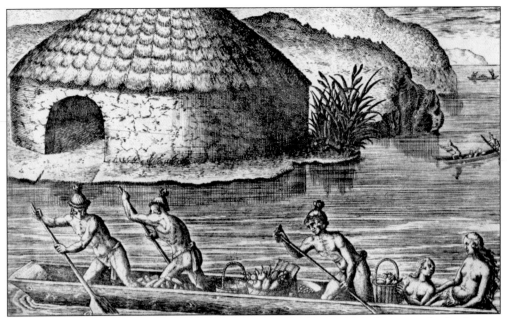

PUBLIC GRANARY. Island produce and crops were stored in low-ceilinged granaries built of stones and earth. These were thickly roofed, layered with palm branches, and built with a special type of soft earth. Granaries were erected close to higher elevations or in the shade of riverbanks for shelter from the tropical sun. Native Americans stored their crops and would return for supplies as needed.

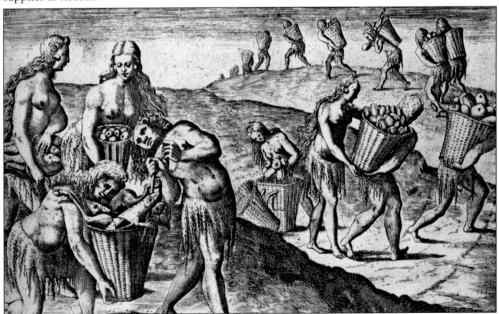

BRINGING IN PROVISIONS. Each year at harvest time, Native Americans gathered a store of wild animals, fish, and even crocodiles. These were placed in baskets and carried by curly-haired tribe members to the storehouse. These supplies were used only in emergencies. When these arose, everyone shared according to his rank; the chief, however, had first choice and took whatever he pleased.

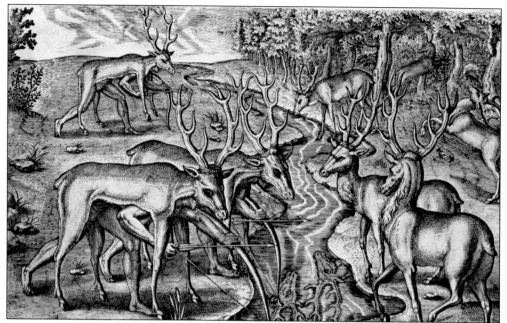

HUNTING DEER. The Native Americans hunted deer by hiding in large deerskins. Placing the dead animal's head upon their own, they peeked through eye holes and approached live deer without frightening them. They chose times when deer came to the river to drink, shooting them easily with bow and arrow. To protect their left forearm from snapping bowstrings, they wore strips of bark. They prepared deerskins using shells for scraping.

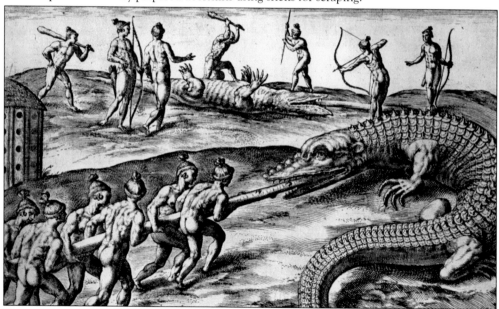

KILLING ALLIGATORS. Near the river, natives erected huts with cracks in them through which hunters watched for gators. Driven to the river for food, hungry gators would give themselves away by their loud bellowing. Sentries inside the huts would alert companions who rushed out with 10-foot, pointed poles that were jammed down the gators' throats. The gators were then turned over and killed by beating and arrows.

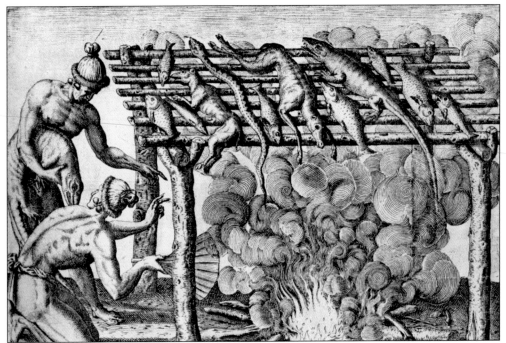

DRYING MEAT, FISH, AND OTHER FOOD. For drying fresh provisions, Native Americans erected a grating of stakes upon four posts. Game was laid above, and a fire was lit below to smoke the meat, thoroughly drying it and thereby reducing the possibility of spoilage and disease in this humid climate.

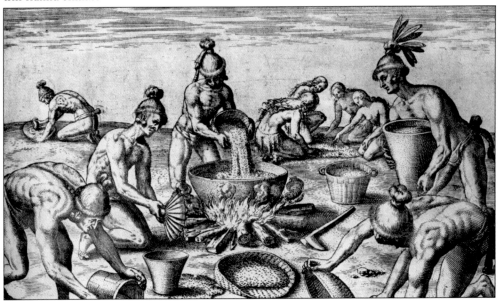

PREPARING FOR A FEAST. At certain times each year, feasts were held. Special cooks were selected and the location was abuzz with preparatory activity. It was reported that Native Americans never over-ate and lived long lives. One chief swore he was 300 years old and his father was still alive and 50 years older! Such "facts" might have shamed Christians, being immoderate in drinking and eating habits, which shortened their lives.

Coacoochee. This Seminole warrior, nicknamed "Wildcat" and "Shrieky Scream," led raids against Americans, including Captain Dummett and Sergeant Ormond on the Halifax River. Famous for escaping jail in St. Augustine and other feats, he was referred to as "the true hero of the Second Seminole War." Recaptured, he was banished to Mexico where he died at 49 of smallpox. His mother said he was made of Florida sands.

OSCEOLA. A leader in the Second Seminole War of 1835, Asi-Yaholo, "Black Drink Singer," drove a dagger into a proffered treaty, stating, "This is the only treaty I will ever make with whites." Captured under a truce flag, he was imprisoned where he died in 1838, at age 34, in full regalia, only to be beheaded by the white doctor tending him. In martyrdom, he achieved the sympathy of his oppressors.

Two

EARLY PLANTATION YEARS

One condition of the 1783 Treaty of Paris between Britain and the newly formed United States was that Florida be ceded back to Spain. This led to the abandonment of many plantations by former British owners, including Richard Oswald. Spaniards found Florida an enormous cash drain and sold land grants. They set some often-ignored conditions—those receiving grants were asked to swear allegiance to the Spanish throne and grantees must practice Roman Catholicism, conditions English Anglicans found intolerable.

Several area plantations operated prior to the Second Seminole War in 1835. In 1803, Henry Yonge received an 850-acre grant, called "Moscheto" (Mosquito) from the Spaniards. It was formerly part of Richard Oswald's abandoned Swamp Settlement and was known as Three Chimneys for a century. Yonge, undercapitalized, gave up his unprofitable effort in 1809. Gabriel Perpall, a Minorcan, was granted 1,800 acres near Mount Oswald, where Oswald built his plantation house during the British period. Perpall later sold the property to Paul Dupont. John Addison of Carrickfergus, County Antrim, Ireland, named his 1,404-acre grant after his hometown. In 1825, he sold his holdings to Colonel Thomas Dummett of Barbados. Dummett bought a nearby plantation from John Bunch and sold the Carrickfergus property to the MacRae brothers. Dummett hired Reubin Loring of St. Augustine to build a sugar/rum mill on the land from Bunch. Twenty-foot walls of Dummett's sugar mill remain about 6 miles north of Ormond Beach. A Scotsman, Robert McHardy, married John Bunch's daughter. He had a 1,000-acre plantation on part of what had been the Rosetta plantation of former British lieutenant governor John Moultrie. Rosetta plantation bordered Captain James Ormond's Damietta property. Ormond was killed by a runaway slave. His son, James Ormond II, took over; his tomb is located in a state park near the Tomoka River.

LORD HALIFAX. During the British occupation of Florida (1763–83), the Halifax River was named to honor George Montagu-Dunk, second earl of Halifax and Knight of the Garter. Some referred to him as "Father of the Colonies" because of his involvement in the New World settlements. He served as president of the British Board of Trade and Plantations.

CAPTAIN JAMES ORMOND. An armed-brig owner trading between the southern United States, West Indies, and Europe, Ormond received an 1816 Spanish land grant north of present-day Tomoka State Park. Later, his son and grandson developed Damietta Plantation on property where James Ormond II is buried. Due to its contributions, the family was honored with the renaming of "New Britain Colony" as Ormond in 1880.

RICHARD OSWALD. Richard Oswald (November 4, 1700–1784), a wealthy Scotsman, was most noted for his pro-American positions in brokering favorable terms giving Americans their heritage of freedom and liberty. Oswald negotiated for England while Ben Franklin, John Jay, and John Adams represented the United States of America, and these men drafted the 1783 Treaty of Paris, concluding our Revolutionary War. Oswald sent the first settlers to Ormond in (about) 1765. He had arrived at the decision to settle in Florida at the conclusion of the worldwide conflict, the Seven Year War, which ceded Florida to Britain for Havana and the Philippines. Within 17 months, the visionary obtained a land grant, dated July 20, 1764, from King George III for 20,000 acres winding along the west side of the Halifax and Tomoka Rivers. Oswald sent three sets of mappers (one was lost to Native Americans, the second lost at sea) before a Spanish-led party succeeded in mapping the area. In February 1765, Oswald advertised for and purchased in Charleston 50 slaves for $7-15 each. Those men were shipped to St. Augustine and, according to some records, by June 1765, had set up temporary housing, were hacking underbrush, chopping down trees, building canals and ditches, and planting sugarcane, seed potatoes, rice, barley, and peas north of what is now Granada Boulevard.

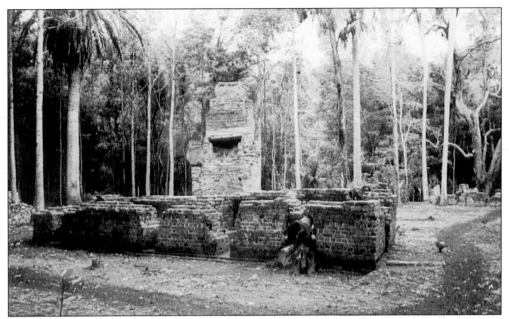

BOILING HOUSE. Around Oswald's distillery, 300 acres of sugarcane were harvested every fall. Cane was ground, lime was added to aid in removing impurities, and the juice was boiled in this four-compartment facility. The thickening juice was constantly stirred, to prevent scorching, by slaves standing on a platform in the rear. The kettles were made of cast iron and sat over the fireboxes, which burned dried cane stocks, or bagasse, and firewood.

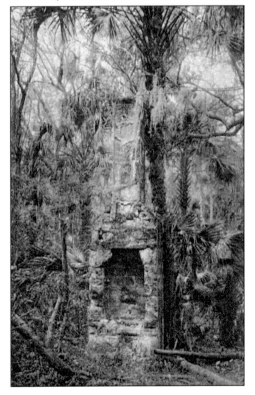

THE THIRD CHIMNEY. Typical of 18th-century, coquina, plantation-house chimneys, the one at Three Chimneys was located 50 yards from the distillery. The carefully cut coquina and tabby mortar reflect the work of knowledgeable craftsmen. Fetid fumes rising from the nearby boiling of sugarcane, with sour yeast at work fermenting the "wash"—the high-sugar-content liquid—and distilling rum, made this a pleasant distance to live from work.

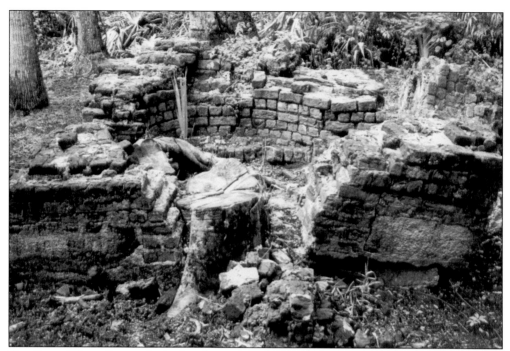

THE STILL. The still, near the boiling house, was constructed of handmade brick and coquina. It measures 6 by 12 feet. Two side-by-side circular fireboxes housed the pot stills, which resembled steam-kettles 4 feet in diameter. The neck of one still fed into a second, thereby double-distilling the rum and achieving an alcoholic proof of 150+. Although this structure was damaged by tree roots, now carefully being removed, its function remains clear.

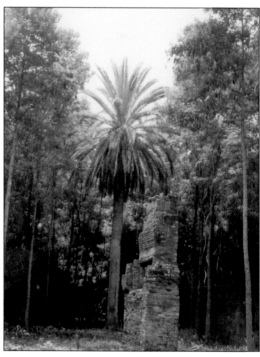

THE DATE PALM. The lowland hardwood hammock surrounding Three Chimneys is 4 to 7 feet above sea level. On it is a canopy of laurel and live oak, sweet gum and coastal pignut hickory, and there is an understory of cabbage palms, magnolia, red cedar, and wax myrtle. Among this diversity grows one magnificent date palm (*Phoenix dactylifera*) with its feather-like leaves bearing clusters of dates and measuring over 3 feet in diameter.

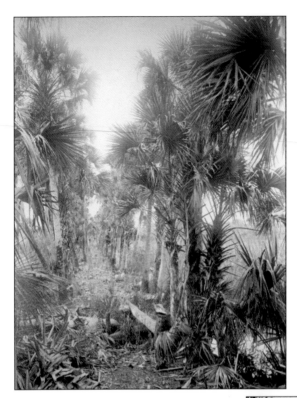

THE LOST CAUSEWAY. Built during the British period as part of Kings Road, this causeway led to the ferry on the Tomoka River near where a bridge was later erected. Surfaced during the grand hotel era with cinders from the hotel boilers, it provided outing opportunities for guests to view the splendid marshes and abundant wildlife in tranquil settings.

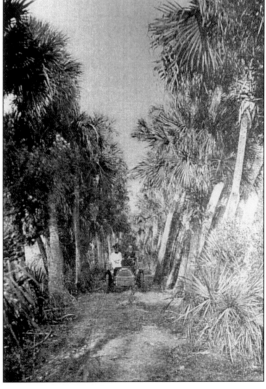

LOST CAUSEWAY LATER. Long considered lost to the past and recaptured by nature, the Lost Causeway was later rediscovered. Its existence is a partial secret because it is only accessible by boat. Distinctive, parallel cabbage palm plantings are visible from a creek that connects it with the Tomoka River.

THREE CHIMNEYS OAK. The hammock surrounding the Three Chimneys site is actually a small upland peninsula with an elevation of about 5 feet. Most of the area's trees are second-growth forest. However, over two dozen magnificent mature live oaks survived the 19th-century logging activities of the Swift brothers. This particular live oak measures 22 feet in circumference and is estimated to be over 300 years old. Pictured from left to right looking at the tree are Shirley and Justin Warner.

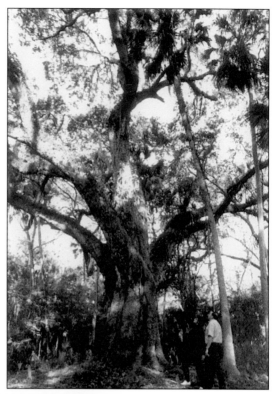

ORMOND FAIRCHILD OAK. The live oak was vital to America's shipbuilding. These magnificent trees, wanted for their buoyancy and strength, had "sides like iron to repel cannonballs," reported papers of the USS *Constitution*, or "Old Ironsides." This live oak, measuring 24 feet in diameter, is the 15th largest tree in Florida and still growing! Dr. David Fairchild, a botanist, believed the tree to be a cross of a live and laurel oak.

LOGGING CART. Loggers lived a Spartan existence in hastily built palmetto lean-tos and log cabins. One main camp was on the Henry Yonge grant, later the New Britain colony. Tomoka Avenue was a logging road where oxen carts hauled logs to the river. Lighters carried them to inlets where they were reloaded onto ocean-going schooners. Volusia County records reveal the oak tree cutting industry lasted until the 1880s.

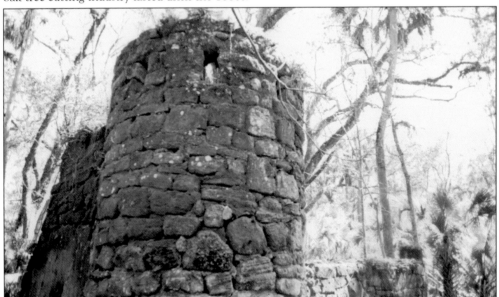

ADDISON BLOCKHOUSE. Located on the Carrickfergus Plantation, this blockhouse was built over the original plantation's kitchen site. During the Second Seminole War of 1835, the blockhouse was attacked by Native Americans, and two soldiers were killed and scalped there. A messenger escaped and sneaked word to St. Augustine pleading for aid. Unfortunately, the plantation struggled, was never profitable, and was subsequently abandoned.

24

TYPICAL EARLY DAY SCENE. A few early pioneers seeking a new life arrived in Florida in covered wagons only to discover uncharted, unexplored territory. Confronted with a hot, steamy wilderness rampant with mosquitoes, wild animals, and snakes, they nonetheless saw its possibility and began the task of clearing land and eking out an often lonely and desperate existence. We who have followed are grateful for the pioneers' futuristic visions.

NOCOROCO SITE. Archaeologists believe this was the setting of the Timucuan village Nocoroco, mentioned in a 1569 memorial to the king of Spain by Captain Antonio de Prado. He noted that the village was situated between two rivers, now known as Tomoka and Halifax. In 1605, Alvaro Mexia, another Spanish explorer, mapped the location as a peninsula between two rivers. Today the area is the Tomoka State Park, which faces the Tomoka Basin.

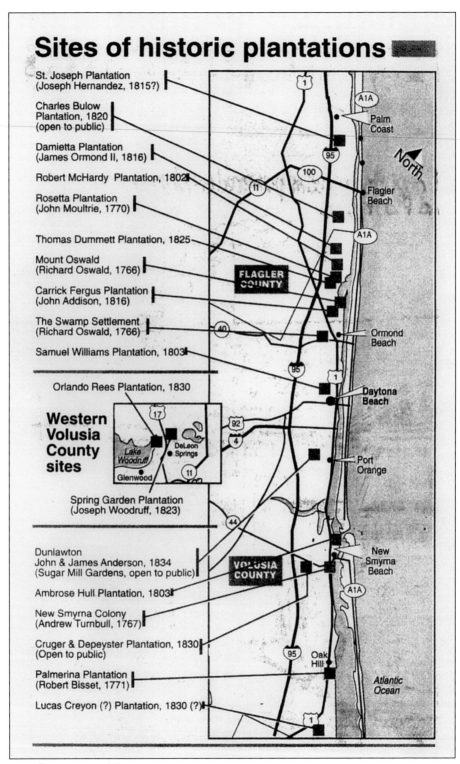

Sites of historic plantations

St. Joseph Plantation
(Joseph Hernandez, 1815?)

Charles Bulow
Plantation, 1820
(open to public)

Damietta Plantation
(James Ormond II, 1816)

Robert McHardy Plantation, 1802

Rosetta Plantation
(John Moultrie, 1770)

Thomas Dummett Plantation, 1825

Mount Oswald
(Richard Oswald, 1766)

Carrick Fergus Plantation
(John Addison, 1816)

The Swamp Settlement
(Richard Oswald, 1766)

Samuel Williams Plantation, 1803

Orlando Rees Plantation, 1830

Western Volusia County sites

FLAGLER COUNTY

Palm Coast

Flagler Beach

Ormond Beach

Daytona Beach

Lake Woodruff
DeLeon Springs
Glenwood

Spring Garden Plantation
(Joseph Woodruff, 1823)

Dunlawton
John & James Anderson, 1834
(Sugar Mill Gardens, open to public)

Ambrose Hull Plantation, 1803

New Smyrna Colony
(Andrew Turnbull, 1767)

Cruger & Depeyster Plantation, 1830
(Open to public)

Palmerina Plantation
(Robert Bisset, 1771)

Lucas Creyon (?) Plantation, 1830 (?)

VOLUSIA COUNTY

Port Orange

New Smyrna Beach

Oak Hill

Atlantic Ocean

Historic Plantation Map.

Three
BEACHSIDE SETTLERS

John Andrew Bostrom and his brother Charles were the first people to settle on the peninsula in what today is Ormond Beach. Attracted by the mighty oaks and sparkling spring water, in 1869 they built a temporary palmetto shack on the east bank of the Halifax River.

Soon to follow was John Anderson, who established the Santa Lucia plantation homes just north of the location where the Hotel Ormond was later erected. About the same time, Joseph Price constructed his "Hammock Home," the Kitchell family settled a little further north, and William Foulke put up his "Foulke Haven," the first house on the beach.

In 1888, Anderson and Price saw their idea of the Hotel Ormond become a reality. In 1889, Bostrom built the Coquina Hotel on the ocean. With the introduction of the automobile and racing, Ormond Beach emerged as the "Birthplace of Speed," further concentrating attention on the area.

As more settlers arrived, Ormond Beach became a mecca for tourists. They enjoyed its mild climate, cool ocean breezes, bountiful orange groves, colorful flowers, and the panorama of beautiful homes nestled among the oaks and palmettos.

John D. Rockefeller purchased The Casements and made Ormond Beach his winter home. The Coquina Hotel was rebuilt and renamed the Bretton Inn, and, with the advent of electricity, the beachside of Ormond became a showplace of elegant homes.

As we approach the end of the 20th century, even with the addition of plush condominiums and beach motels, this friendly community retains its historical significance and small town atmosphere for all to enjoy.

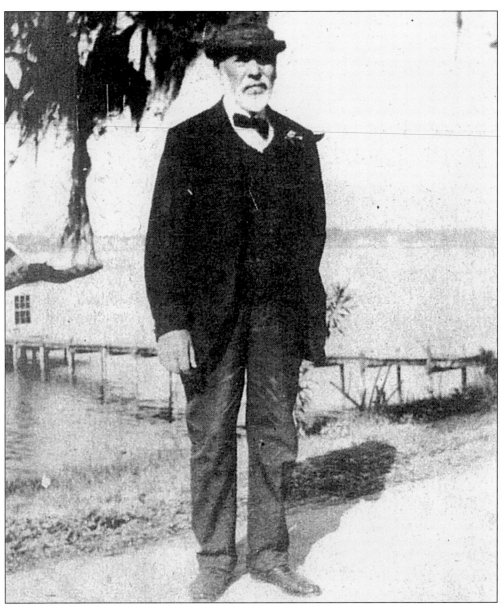

JOHN ANDREW BOSTROM. As the first permanent resident on the beachside and the man responsible for convincing the Corbin Lock Company of New Britain, Connecticut, to establish their colony on the mainland, John Andrew Bostrom (1836–1927) had an interesting history. He was a Swedish seaman who came to America in the 1860s and joined Union forces at Port Royal, South Carolina. He sailed on government transports until the end of the war. Being strongly opposed to slavery, Bostrom aided many African Americans in their flight to freedom. After the war, he visited St. Augustine; Bostrom was charmed by the abundant oranges and decided to relocate to Florida and grow oranges. He sent for his brother Charles, a farmer, to join him. They hired a former slave, Israel, to guide them down the Matanzas River and then 14 miles overland to the Halifax. In 1868, they settled on the east side of the river in what is now Ormond Beach. Their first dwelling was a crude palmetto shack. The above picture shows the dignified elderly gentleman with a twinkle in his eye at age 91.

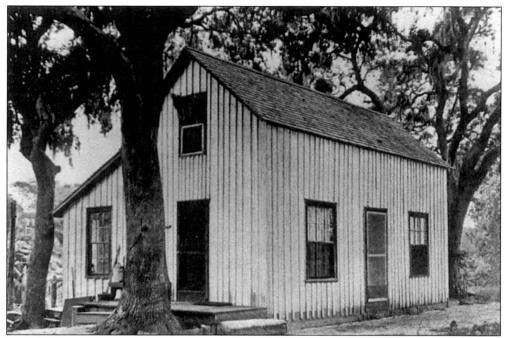

FIRST BOSTROM HOUSE. In 1869, Andrew and Charles Bostrom built this first wood-frame house on the east bank of the Halifax. It was situated on the south side of the location now called Riverside Circle. This was also the first house to be located on the peninsula between St. Augustine and New Smyrna Beach.

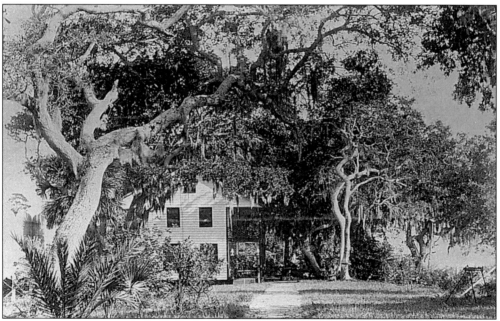

SECOND BOSTROM HOME. In 1871, Andrew and Charles sent for their sisters Helen and Mary to join them. They built a larger house immediately north of the first house. They wanted room to accommodate the many travelers arriving in the area. In 1874, Andrew married Mary Fitch Baker of Salem, Massachusetts. The first house stood until 1903.

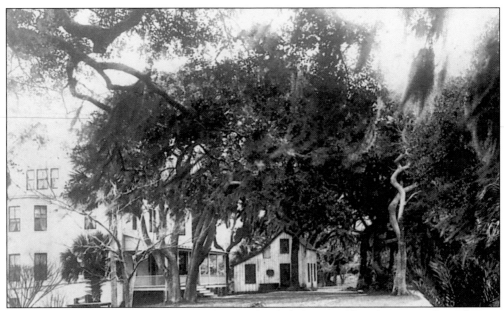

FIRST BOSARVE. In 1903, Andrew and Mary decided they could make money by enlarging the house and taking in boarders. A 14-bedroom, three-story home, which Bostrom named "Bosarve" (home place in Swedish), was built on the foundations of the second Bostrom home. With the two Swedish sisters cooking, Bosarve earned the reputation of having the best food and the most comfortable beds in Florida.

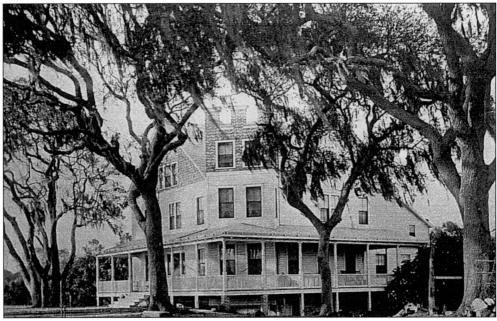

A VIEW OF BOSARVE FROM THE SOUTH IN 1903. A wide porch, or veranda as Andrew called it, extended on two sides, and the many big shady oak trees provided a delightfully cool and breezy meeting place for guests, visitors, and friends. Filled with guests during the winter months, Bosarve was "like a palace for the Bostrom children in the summertime," recalls John A. Bostrom's grandson, Don.

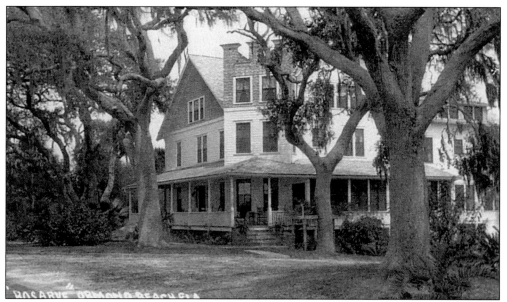

BOSARVE IN 1925. Andrew's son Lars decided to enlarge and remodel Bosarve. All electric wiring and plumbing was replaced, and the house was expanded to 20 bedrooms and 14 baths. The porch was enclosed on the south side, and a large completely equipped kitchen was added. Over the years, many famous people stopped at Bosarve, including John D. Rockefeller, Henry Ford, Leota Cordatti-Coburn, and Leonard Knox.

INDIAN MOUND. South of Bosarve, in the front yard of the present-day Hyatt Brown residence, was an Indian mound where children played on its grassy knoll. A 1928 guest, Henry Britt from Saginaw, Michigan (a retiree from the Smithsonian), saw the bones and artifacts the Bostrom children had dug from the mound. Britt arranged for excavation, and large quantities of bones, pottery, and artifacts were sent to the Smithsonian.

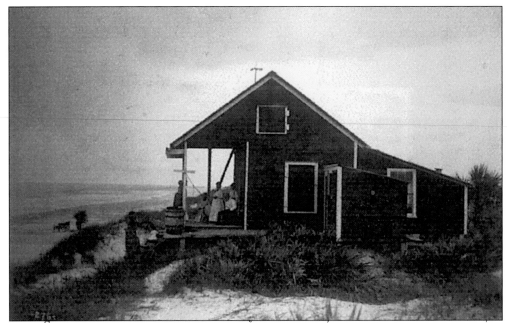

monthly. Rumor has it that John Anderson lived here briefly.

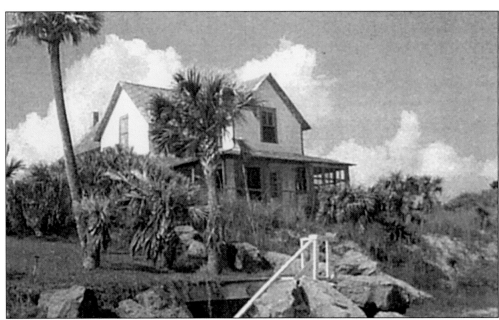

FIRST HOUSE ON THE BEACH. Skeptical villagers felt it foolish to build a full-time residence on the beach. Thus, when this house was being constructed, they referred to it as Foulke's Folly instead of *Foulke Haven*, as the owner wished. Built of pine in the late 1880s, it was located north of the present-day Neptune Avenue. It had ten rooms, four dressing rooms underneath, and was heated by fireplaces.

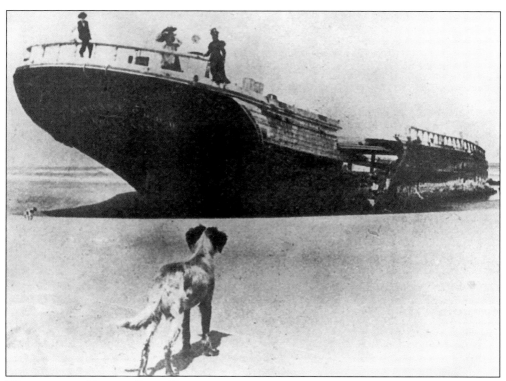

WRECK OF THE NATHAN COBB. On December 5, 1896, this schooner, loaded with cross ties and lumber, foundered near Ormond Beach. Three men drowned: two crew members and a local man, Freed Waterhouse, in a daring rescue attempt. Salvaged pieces of the vessel were used in many ways. Billy Fagen built a home (still standing) on Orchard Lane on property then owned by John Anderson with some of this material.

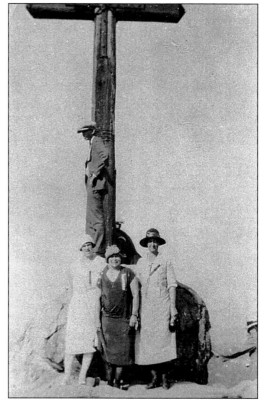

MONUMENT TO THE NATHAN COBB. Erected in memory of the tragic event, this monument no longer exists. It once marked the site where the *Nathan Cobb* wrecked, near the present Cardinal Avenue beach approach. Identified in this photograph are Lars Bostrom, top, and Lucile Bostrom, bottom center.

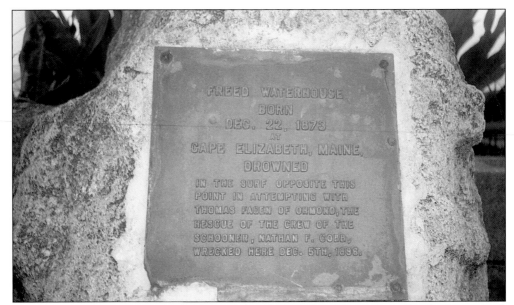

FREED WATERHOUSE MARKER. This bronze-plated stone, from the stone wall at his homestead, was placed as a memorial to Waterhouse. The inscription reads, "Freed Waterhouse, born Dec. 22, 1873, Cape Elizabeth, Maine drowned in the surf opposite this point in attempting, with Thomas Fagen of Ormond, the rescue of the schooner crew. Nathan. F. Cobb wrecked here Dec. 5, 1896." The marker is preserved at the Casa del Mar Hotel on SR A1A.

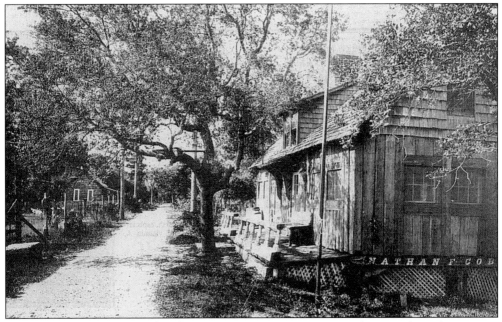

NATHAN COBB COTTAGE. This three-room cottage remains a residence and can be seen on Orchard Lane north of the Ormond Heritage Condominiums. Salvaged timber from the *City of Vera Cruz* was used by William Fagen to build it. In 1914, Fagen also built a home on stilts on the Three Chimneys property. A separate kitchen, connected to the Cobb house by a shingled roofed "dog trot," was a common design of the time.

TALAHLOKA. Located directly north of the Ormond Heritage Condominiums and just east of John Anderson Drive, Talahloka was built of palmetto logs. The hunting-lodge has four rooms on two floors with a center fireplace and four openings on each floor. Built in a woodsy setting, the structure still maintains a special charm as urbanity surrounds it. This building was also on the Santa Lucia Plantation owned by John Anderson.

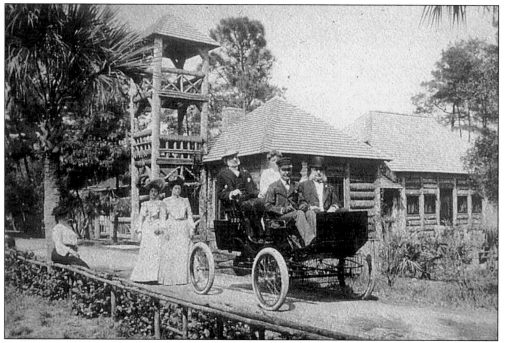

THE STUDIO. Depicted here are visitors enjoying an outing. Behind them is a lookout tower to climb and view the surrounding sights from across the river and to the ocean. The connected building was once a small restaurant and tearoom.

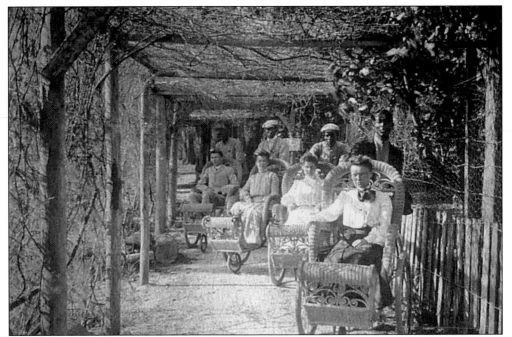

"AFRO-MOBILES." Not considered a derogatory term by the users (did anyone ask the pedalers?), these interesting modes of transportation are seen beneath a grape arbor. Hotel Ormond guests often took scenic rides to view the area, its surrounding homes, the beach, and orange groves, and to enjoy the breezes along the riverside.

TRAPPERS LODGE. John Anderson and his cousin Samuel Dow, also from Maine, paid $125 for scrubland overgrown with virgin pines and palmettos. On it they built Trappers Lodge. This cabin, now demolished, was so named because of the wild animals the men hunted on the property. Meat was consumed and animal skins were stretched on exterior walls to dry.

RED TOP HOME. During the early hotel years, small cabins were made available to rent for the winter season on Santa Lucia Plantation property. This particular one was rented by Miss Fanny Day. One amusing letter from her noted that she had her Union Church Sunday School girls spend the night. Local boys, vying for attention, or wishing to frighten the young ladies, threw grapefruit at the house.

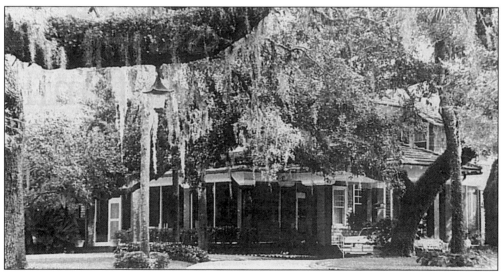

HAMMOCK HOME. Built on a "gentle rise of land," this inviting home of Joseph Price, his wife, and son, on John Anderson Drive, is a short distance from Neptune Avenue. Surrounded by huge live oaks, the interior has a high ceiling and tall windows for cooling. With its screened-in porch and red-tiled roof, it provides a tranquil glimpse of bygone days.

37

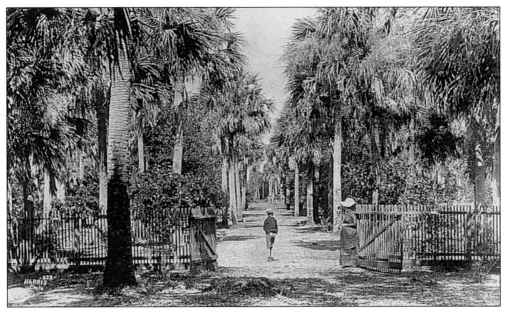

Number Nine Plantation Entrance. Chauncey Bacon, a Connecticut Yankee, known as "the Duke" because he wore a top hat in our wilderness, purchased this property in 1876. He called it so, having previously investigated eight other potential home locations. He built a palmetto-thatched hut for his family and began clearing land. Later, he constructed a small cottage. He raised citrus, and his products became nationally famous.

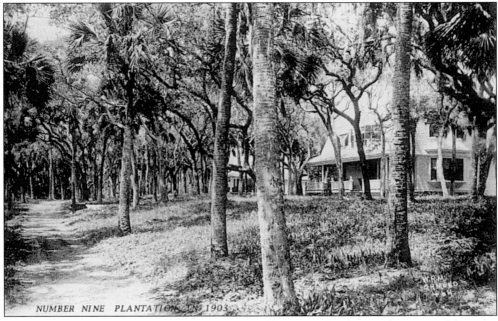

Number Nine Plantation. Bacon's third and final home used mahogany logs rescued from the wreck of the *Vera Cruz* in its construction. Built on 172 acres stretching from river to ocean, the home is approximately 5 miles north on John Anderson Drive from the present-day Granada bridge. Many parties and picnics for visitors and local pioneer families were hosted here, as the Bacons were gracious, outgoing people.

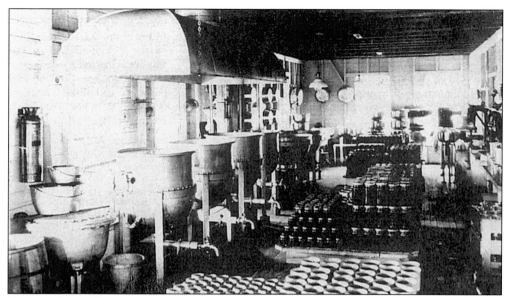

NUMBER NINE PRESERVING PLANT. From citrus and other fruit grown on their property, Mrs. Bacon and her son put up great quantities of jellies and jams. A humble barn-business grew into a well-known factory and, because of the quality of the products, mushroomed into a thriving factory. When the hotel opened, guests would visit the groves by boat to purchase preserves. Later, when the landscape was cleared for a crude road, visitors used vehicles.

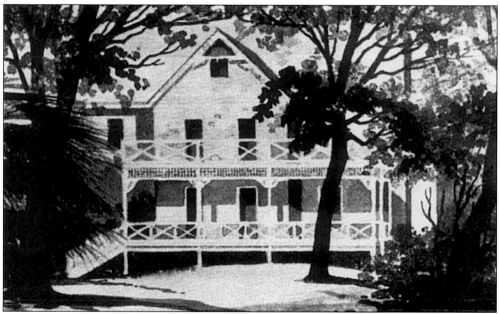

THE ANCHORAGE. One of Chauncey Bacon's house guests, after hearing enchanting tales of Florida living, purchased 80 acres from John Anderson and began a grove and, on "Palmetto Point," a boatyard. Captain Shaw's home on the land, which also ran west to east, from river to ocean, was dubbed The Anchorage. Torn down in 1986, it was replaced with a modern house.

39

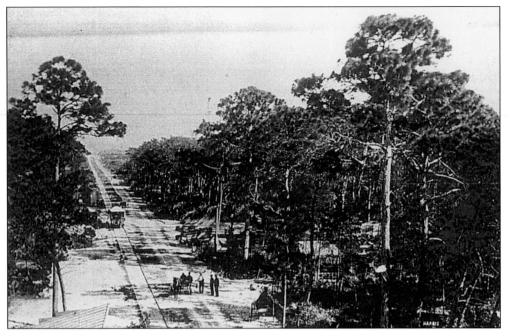

Looking East on Granada. Granada Avenue on the beach side resembled much of the surrounding countryside roads. Its straight, wide path bisected the peninsula from river to ocean. Note the streetcar on the tracks that bore passengers to and fro. On the hard-packed road can be seen a horse-drawn cart and several bystanders, a far cry from the hustle and bustle of today.

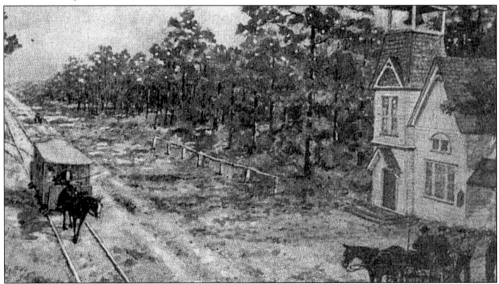

St. James Church. This was a view of East Granada in 1891. Two women guests at the hotel during the winter season of 1889–1890 organized a band of Episcopal worshippers. In 1898, the Reverend Joseph McDonald McGrath became the group's priest at $90 a month. Through the years the street became quite busy and noisy. On July 8, 1921, the location of the church was changed to a more spacious lot on Halifax Avenue. The old church became a wing of the new church.

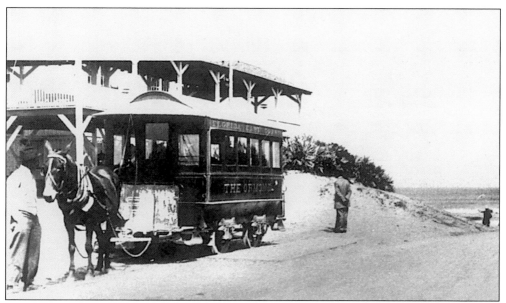

ORMOND'S STREET CAR. In 1915, this tram began servicing the community. It only lasted a short time, as the need for it was minimal. However, during its serviceable years, it provided local color and amusement for riders and onlookers alike. The mule never expressed his opinion.

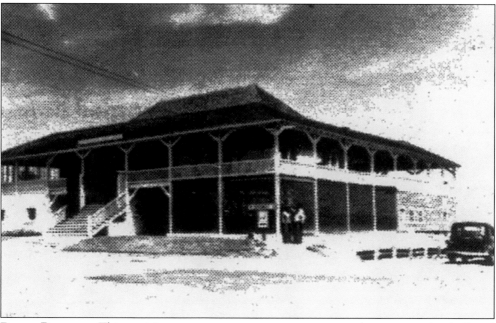

BEACH PAVILION. This enticing, open, two-story structure was used as a recreation hall and enjoyed by visitors during the winter season. Locals often took advantage of the pavilion's shady environs during hot summer months by enjoying picnics under its eaves. Later, the building was used by golfers after it was purchased by the Hotel Ormond owners. It was located on the northeast corner of present-day Granada Boulevard and A1A.

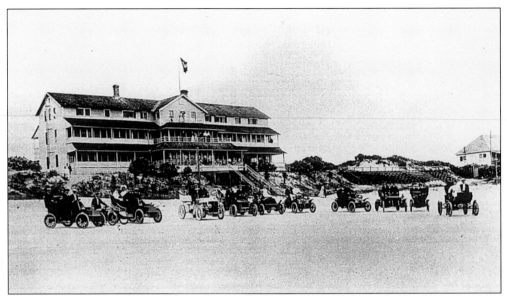

BRETTON INN. John Anderson and Joseph Price purchased the Coquina Hotel in 1903. They renamed it the Bretton Inn after the Bretton Woods Hotel in the New Hampshire White Mountains, famous as the 1944 post-war site of the international conference establishing the World Bank. The men also managed the Mt. Pleasant House and Mt. Washington Hotel. Ormond's Bretton Inn was razed to build the modern Coquina Hotel the summer of 1923.

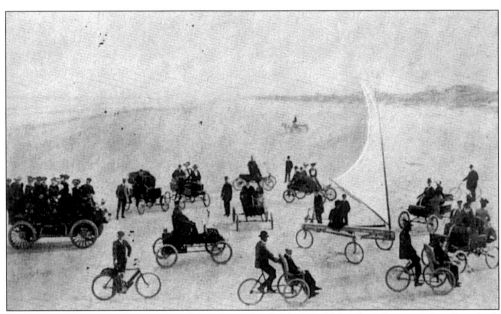

BEACH VEHICLES. By the 1900s, all manner of vehicles could be found on our hard-packed, wide, sandy beach. Seen here is a sand sailer with its three bicycle tires and triangular white sail, along with bicycles, automobiles, Afro-mobiles, and a touring car overflowing with visitors enjoying a beach outing.

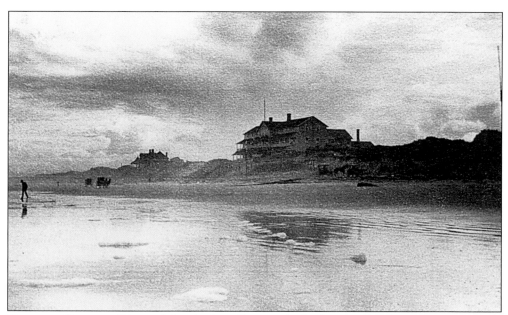

ORIGINAL COQUINA HOTEL. John Andrew Bostrom built this imposing structure in 1889 on dunes rising just south of the Granada Avenue approach. With its magnificent view and inviting appearance, the hotel held great hope for luring visitors to the beach. It was named for the coquina wedge-clam (*donax variabilis*) found in our waters and sands, whose colorful, butterfly appearance make it a favorite of tourists and locals alike.

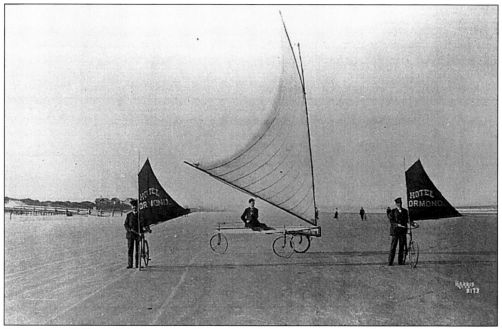

SAND SAILERS. One of the most popular pieces of sports equipment in the early days at Ormond was the sand sailer that glided or smoothly sailed on the firm, hard sand of the beach. It took a fair wind or a tricky breeze to operate it successfully. If a rider could master the elements and the two- or three-wheeled craft, he was in for a magical thrill.

43

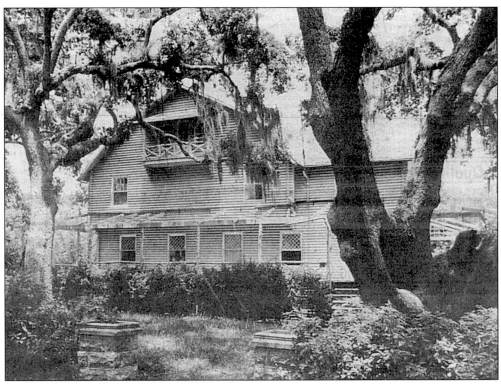

GRAY OAKS. Before its destruction several years ago, this was one of the most interesting houses on Riverside Drive. It was a tall, solid-looking structure constructed of heavy, gray cedar logs. There were many stories whispered about the building's gambling activities, when sporting gentlemen tried their luck at a big table with a roulette wheel. Other attractions were the many photos of racehorses displayed along the walls of the gambling room.

RIVER ROAD. This narrow, meandering, tree-lined lane was canopied by the "Bostrom Oaks" as the road wound along the river to its west. Originally referred to as River Road, after it was paved it became known as Halifax Drive. In the 1930s, Halifax Drive's name was changed to Riverside Drive. Now a one-way street south of Granada Boulevard east of the bridge, it is one of the most charming drives in Ormond.

Four

NEW BRITAIN COLONY
AND THE BIRTH OF
ORMOND

As a lock manufacturer in New Britain, Connecticut, Philip Corbin had many longtime and elderly employees. He wanted to do something for them in their retirement years, so, in 1873, Corbin sent Daniel Wilson, George Millard, and Lucious Summers, three trusted employees, to Florida to find a large, suitable retirement location.

The trio walked down the beach along the Atlantic Ocean from St. Augustine. They found a well-marked trail leading west from the sand dunes and followed it to the home of a Swede, John Andrew Bostrom, the first full-time settler in that area who lived next to the Halifax River. Bostrom boated the trio across the river to see the 630-acre Henry Yonge grant fronting the west bank of the river. The men deemed it perfect and purchased it as well as some nearby government land.

Corbin divided the land into 144 lots and held a drawing among his employees for first pick. Wilson and Millard returned to build the Colony House where settlers lived until their new retirement homes were completed.

As more settlers arrived, they recognized the need for a village government. Meeting at the Dix House, the settlers voted on basic laws and a name for their community, previously called New Britain. James Francis, a prominent merchant, offered a bag of sugar to any man who would vote to retain the old name.

In a vote on April 22, 1880, the name Ormond was unanimously chosen. Ormond's first mayor was Daniel Wilson; aldermen were John Andrew Bostrom, Charles McNary, J.P. Belden, James Francis, and J.C. Seiser. E.W. Craig was elected town clerk and E.S. Ellsworth, town marshal. These choices initiated the beginning of the City of Ormond, later to become Ormond Beach, which in 1999 boasts 34,000 residents and a vastly expanded city limits.

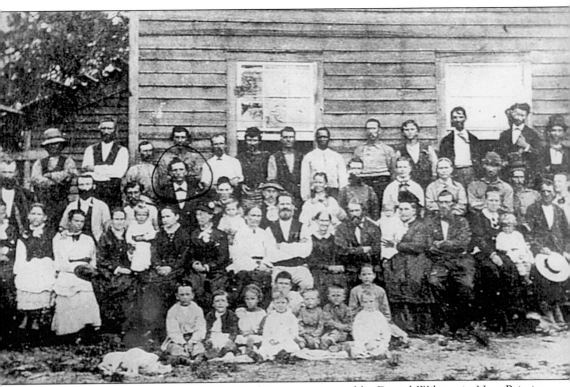

PIONEERS AT COLONY HOUSE. The first house, constructed by Daniel Wilson, in New Britain provides the background for a community gathering on January 29, 1878. This house was on the south side of what are now called Tomoka Road and Beach Street. The encircled man is John Anderson. Early settlers lived difficult lives, but ones that were interdependent and socially gratifying.

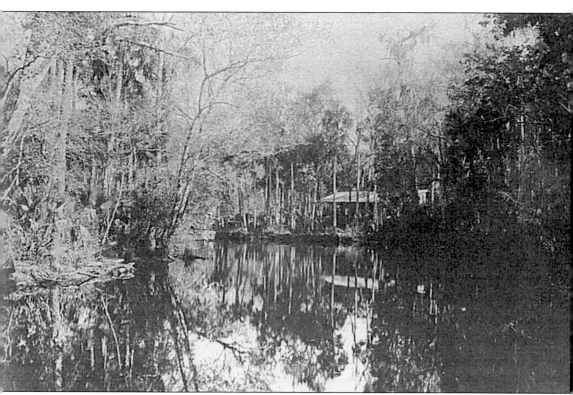

THE TOMOKA CABIN. After the opening of the Hotel Ormond, this cabin was built beside the reflecting waters of the Tomoka River. Pleasure boats would bring hotel guests to this spot to enjoy picnic lunches. Often they returned by land in carriages. One story tells of the day a group was mistakenly left overnight. The weather grew so cold the stranded guests burned furniture for heat.

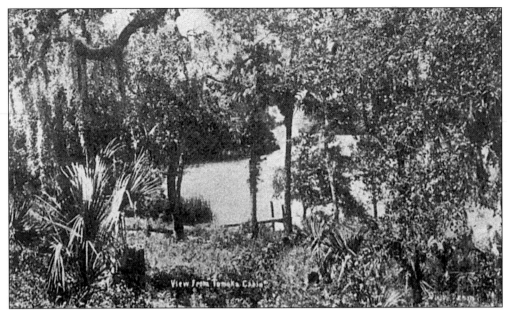

VIEW FROM TOMOKA CABIN. This picturesque scene by the river, with the rustling palmettos and tall trees bearing Spanish moss-laden branches, provided a restful setting for the many visitors who came to enjoy Ormond's mild winter months. Abundant wildlife and migratory birds also thrived in this sparsely human populated area.

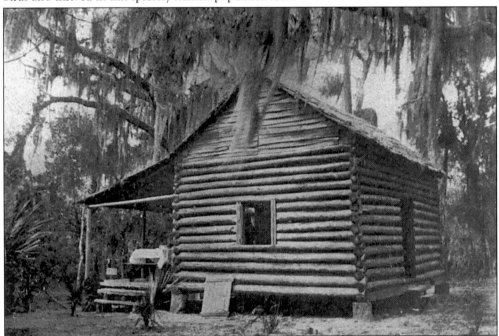

MISENER'S LANDING CABIN. Although this picture is dated April 16, 1904, from the exterior view it resembles many such log buildings that have been recycled in architectural style. For example, log cabins are regaining popularity as vacation homes. This structure is thought to be the original Misener Cabin, one of few at the time built along the river. A street bearing the owner's name is located in Ormond.

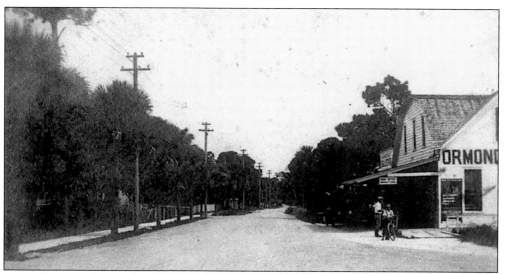

JAMES FRANCIS STORE. Looking north on Palmetto (now Beach Street), its junction with Tomoka was the site of the local dry goods store. The owner lived across the unpaved road. A long dock extended into the river and provided moorings to the boats that supplied the establishment and community with welcomed merchandise. As in other villages, the store was a popular gathering spot and unofficial meeting place.

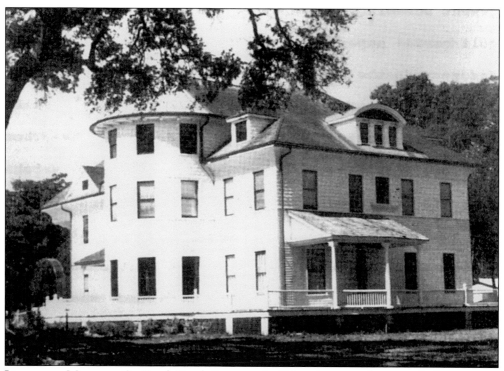

LIPPINCOTT MANSION. On South Beach Street, and still in existence today, appears this imposing structure. The Lippincott sisters were early owners and operated this home as a boarding house to accommodate visitors and guests. George Rigby, Ormond mayor for several terms, boarded here. This section of town was originally platted as Melrose.

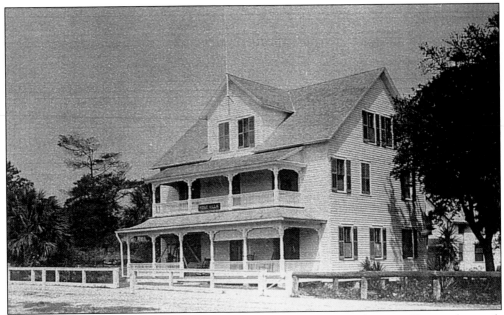

ROSE VILLA. This former boarding house presently functions as a real estate office on the north side of Granada Boulevard. In earlier days there was a need in the burgeoning community for temporary accommodations because there were no motels. Locals often came here to eat, and Rose Villa was well known for its sumptuous Thanksgiving table.

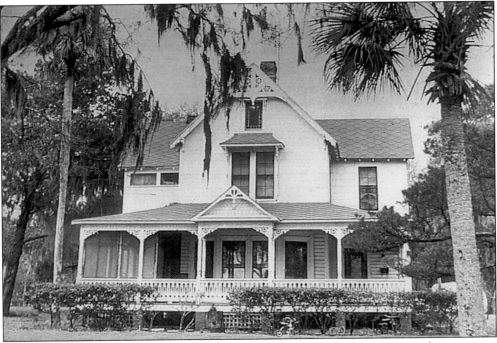

THE BORDEN HOUSE. This charming home, on the site of the Colony House, no longer exists. The Borden family of Walkiel, New York, resolved to make Ormond its winter headquarters and purchased the Colony House where Mr. Borden spent his final days. He was a descendant of Gail Borden, who, in 1856, developed Condensed Eagle Brand Milk.

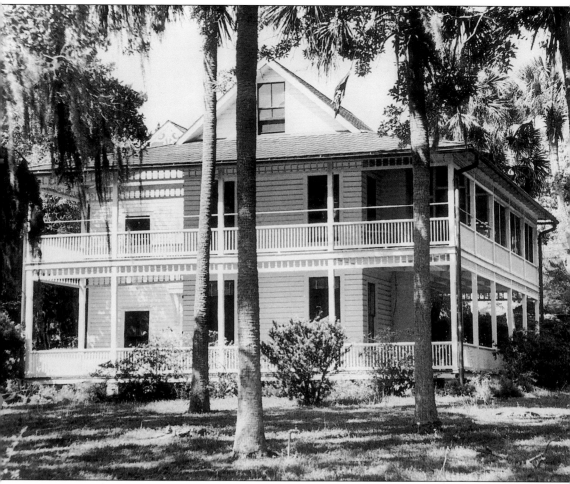

AMES HOUSE/THE PORCHES. This home is located across the street from Melrose House. Blanche Butler Ames purchased it and several others for her family to reside in during the winter seasons. The family had appreciated the amenities of the Hotel Ormond but needed more commodious accommodations. General Ames was a favorite golfing partner of Mr. Rockefeller. The accomplishments of both husband and wife were noteworthy.

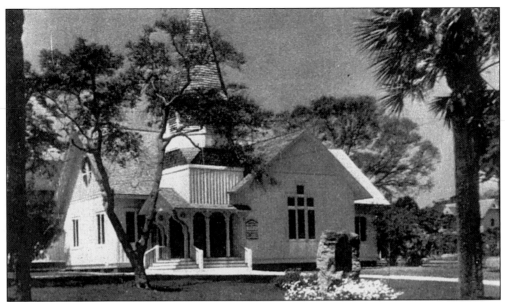

ORMOND UNION CHURCH. The building materials for this quaint church were brought down river on boats because this mode of transportation was easiest, and, for most stretches, the only one available. The loaded boat capsized and everything had to be salvaged. Quite a task! Elisha Pinkerton, the first minister, came from Kentucky to serve. The building was later enlarged and modernized. Rockefeller, while in residence, often attended services here.

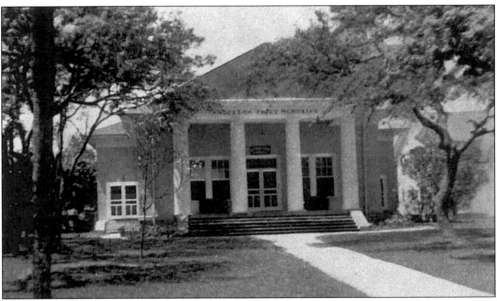

ANDERSON AND PRICE MEMORIAL LIBRARY. Named to honor the contributions of two astute businessmen, this Grecian-style building located on North Beach Street originally served as a library and is the home of the Ormond Beach Woman's Club. That organization, formed as the Village Improvement Association, was dedicated to service and upgrading community standards. Formerly open to both sexes, Mrs. Joseph Price was its first president, and "Aunt Nell" Pinkerton, the minister's wife, a prominent member.

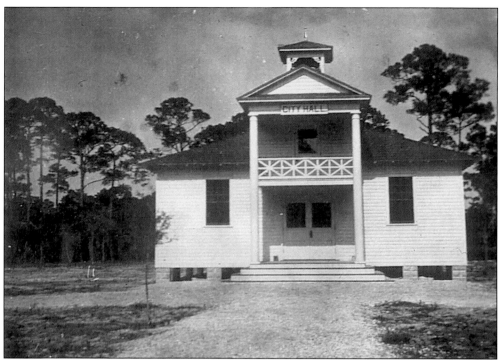

ORMOND CITY HALL. Strangely, the meaning of the term "city hall" has evolved through the years. This building was not built for city business functions or for carrying on the official aspects of running a town. Voting was done here, but it was used primarily for social gatherings because it was considered the town meeting place. Dances and social happenings were often held at the old Ormond City Hall, a magnet for fun and fellowship!

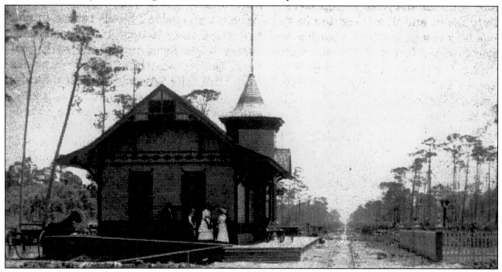

ORMOND RAILROAD STATION. This station originally stood on the west side of the railroad tracks north of Granada. Utley J. White built the first railroad from Rolleston (near Palatka, northwest of Ormond) and probably this station. When Henry Flagler laid his railroad's tracks down the East Coast and bought the Hotel Ormond, this station was demolished. Flagler wanted a railroad station on the tracks' east side for the convenience of his hotel guests.

ORMOND PUBLIC SCHOOL. This one-room schoolhouse stood on the corner of Ridgewood and Lincoln Avenues, occupying a small clearing with barely enough room for the children to play. It was constructed in 1879. Hotel guests would often visit to listen to students' recitations. In earlier times, Mrs. Chauncey Bacon taught six boys in a small cabin on West Granada for six weeks each year.

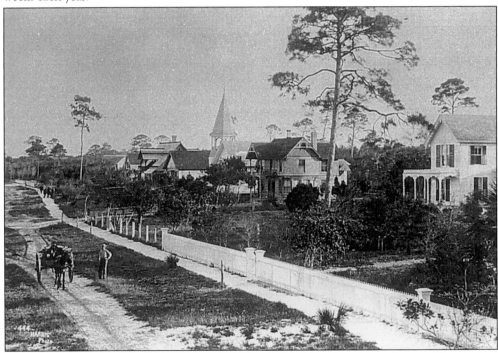

MAIN STREET. The New Britain colony, which became Ormond and then Ormond Beach, had its main road running north-south along the west side of the Halifax River. It was originally called Palmetto Street because of the profusion of palmetto plants that flourish in Ormond's sandy soil. Along with cabbage palms, these plants were, and still are, abundant in the Ormond area. As the town grew, the street was renamed Beach Street.

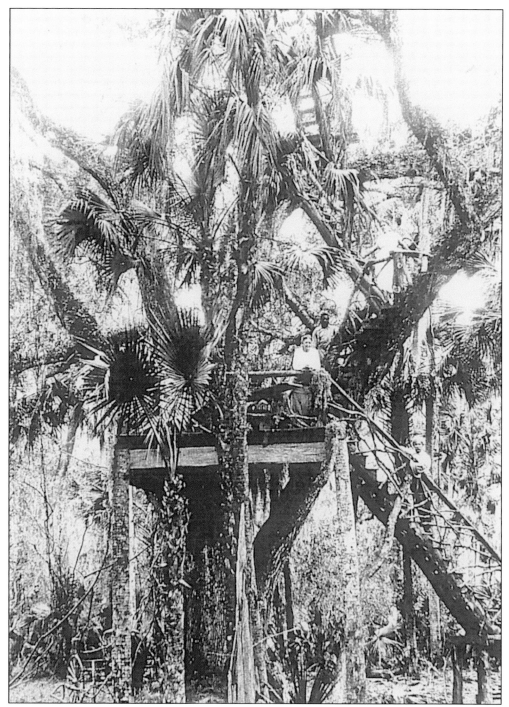

FAGEN'S TREE-HOUSE. Text on this 1915 postcard states that Billy Fagen cleared the underbrush and made a regular "park" here. He moved the alligators, cleaning out an ancient indigo vat for them. The magnificent tree still stands on the Three Chimneys property, and notches and grooves from Fagen's construction are still visible to its top. From that airy cage, looking across the Halifax River, could be seen the vast expanse of the Atlantic Ocean.

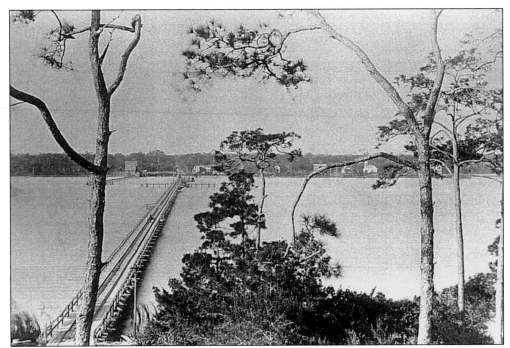

ORMOND BRIDGE. Looking west from the peninsula, on the left, is the dock at James Francis's store, a two-story building at the pier's end. The tree branch on the right appears to be embracing the Union Church across the waterway. Note the rails on the one-way bridge and the horse-drawn buggy straddling them. John Andrew Bostrom constructed the bridge for Flagler, and Joseph Price was given the honor of being first to cross it.

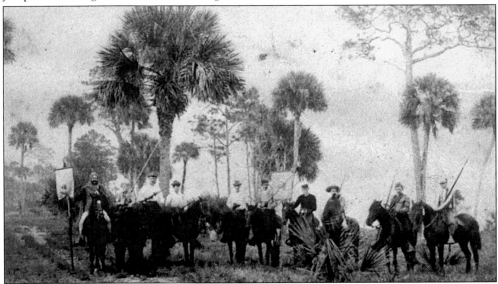

RING TOURNAMENT. This popular form of entertainment was introduced by John Anderson and continued for years. Like knights jousting in days of old, men wore medieval costumes, rode spirited horses, and paraded in review for hotel guests and residents. Area citizens looked forward to the events with mounting anticipation, and the participants relished the opportunity for a break from daily routines to display their skill with lances.

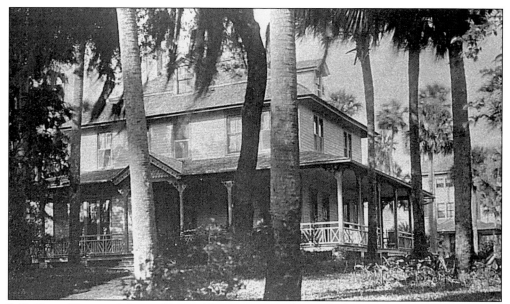

L.B. Knox Home at Mound Grove. This magnificently porched structure with its tall windows overlooks High Bridge Road, which hugs the winding banks of Bulow Creek. The house was built on the 110-acre Knox and Beed Plantation, and the designation Mound Grove came from one of the largest middens in the area, discovered nearby. Bulow Creek, a dredged canal, over which two bridges were built, is one of the most scenic drives in America.

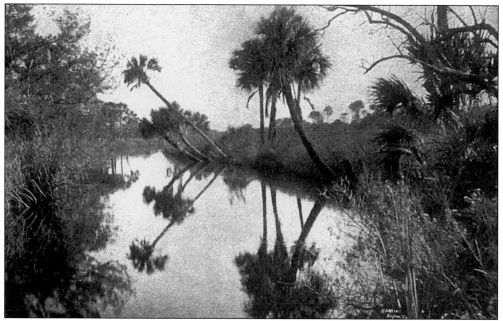

Thompson's Creek. This awe-inspiring view is one of the many breathtaking sights along the lattice of waterways that meander through Ormond's lush environment. Labeled a "typical Florida stream," one must now be a questing wanderer to discover such a peaceful sight today. This photograph was taken in 1905 from the old causeway.

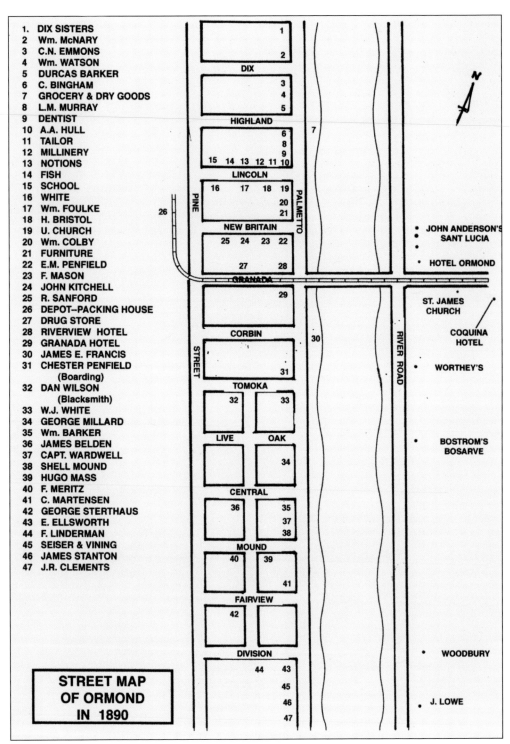

1. DIX SISTERS
2. Wm. McNARY
3. C.N. EMMONS
4. Wm. WATSON
5. DURCAS BARKER
6. C. BINGHAM
7. GROCERY & DRY GOODS
8. L.M. MURRAY
9. DENTIST
10. A.A. HULL
11. TAILOR
12. MILLINERY
13. NOTIONS
14. FISH
15. SCHOOL
16. WHITE
17. Wm. FOULKE
18. H. BRISTOL
19. U. CHURCH
20. Wm. COLBY
21. FURNITURE
22. E.M. PENFIELD
23. F. MASON
24. JOHN KITCHELL
25. R. SANFORD
26. DEPOT--PACKING HOUSE
27. DRUG STORE
28. RIVERVIEW HOTEL
29. GRANADA HOTEL
30. JAMES E. FRANCIS
31. CHESTER PENFIELD
 (Boarding)
32. DAN WILSON
 (Blacksmith)
33. W.J. WHITE
34. GEORGE MILLARD
35. Wm. BARKER
36. JAMES BELDEN
37. CAPT. WARDWELL
38. SHELL MOUND
39. HUGO MASS
40. F. MERITZ
41. C. MARTENSEN
42. GEORGE STERTHAUS
43. E. ELLSWORTH
44. F. LINDERMAN
45. SEISER & VINING
46. JAMES STANTON
47. J.R. CLEMENTS

STREET MAP
OF ORMOND
IN 1890

1890 ORMOND STREET MAP.

Five

MᴄNᴀʀʏs ᴀɴᴅ Oᴛʜᴇʀ
Eᴀʀʟʏ Sᴇᴛᴛʟᴇʀs

After the Second Seminole War ended in 1842, farming families moved here from Georgia and the Carolinas. Many families settled on the west bank of the Tomoka River, while others established homesteads about 5 miles west of the Halifax River, constructing log homes and planting orange groves. Some family names survive to the present: Hull, Bennett, Winn, Davis, Groover, Harper, Wingate, Cone, and Minshew. At the time, their Tomoka Settlement was the largest of its kind in east Volusia County with its school, full-time teacher, and church. Unfortunately, no traces remain except a graveyard with headstones bearing the names of Confederate Civil War veterans.

The McNary family arrived in Ormond in 1874, and many descendants are still residents of our city. The prominent family played a key role in the formative years of Ormond; their influence was felt in the citrus business, construction, and politics. Later, many of the McNary men served their country in its wars.

The disastrous freeze of 1894–1895 destroyed inland citrus groves and forced most of these families to move to Ormond to work in groves along the Halifax River that had been spared freezing by their proximity to water. In 1910, these settlers relocated their church to Ormond, near the intersection of then Tomoka Avenue and Canal Street. In 1988, that property was purchased for commercial development. The Ormond Beach Historical Trust persuaded the city to move the Pilgrim's Rest Primitive Baptist Church to the northwest corner of the Granada bridge. Civic groups, including the Ormond Beach Historical Trust Board of Directors, continue to use it for meetings.

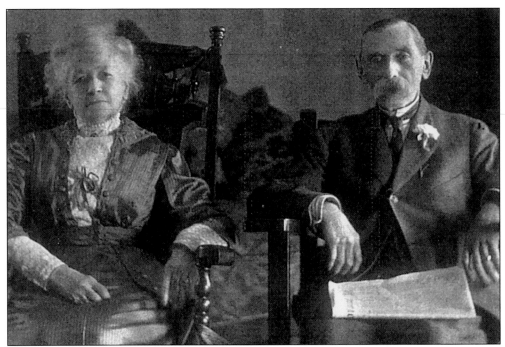

WILLIAM AND REBECCA MCNARY. William McNary had been in Florida briefly during the Civil War. Some years later he retired from the Corbin Lock Company in New Britain, Connecticut. McNary returned here in 1874 and settled on land extending from present-day Dix Avenue northward to Hernandez. The McNarys' citrus grove sprawled from what is now Yonge Street to Nova Road. The family built one of the first homes on the mainland side of the Halifax River.

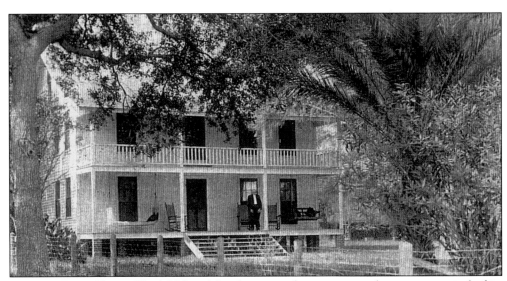

MCNARY FIRST HOME. The McNarys' first home, a white, two-story house, was typical of its period. Note the porch swing on the left, perfect for lounging and dozing. The one on the right provided a comfortable place to swing and gaze at the Halifax River. In the days prior to air conditioning, porches were popular features and wonderful gathering spots for storytelling before the invasion of television.

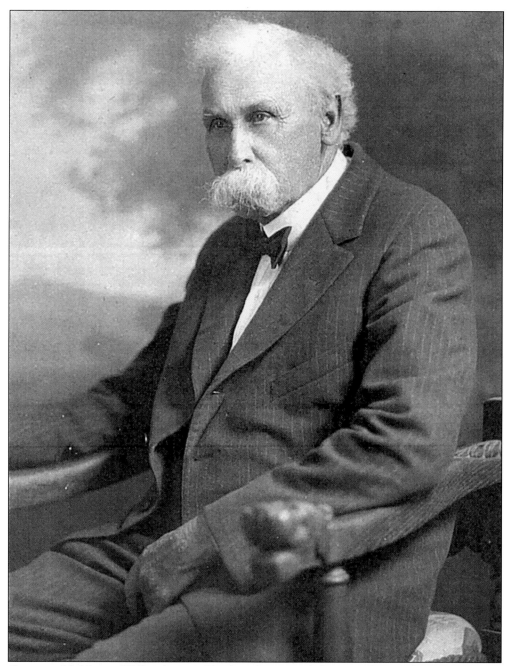

CHARLES MCNARY. William's son Charles also retired from Corbin Lock Company and relocated here. On April 22, 1880, at the Dix House town meeting, Charles was appointed one of the judges to count the votes that resulted in the incorporation of the fledging New Britain settlement. Later, he served his community as councilman, mayor, justice of the peace, and secretary/treasurer of Ormond's Building and Loan Association.

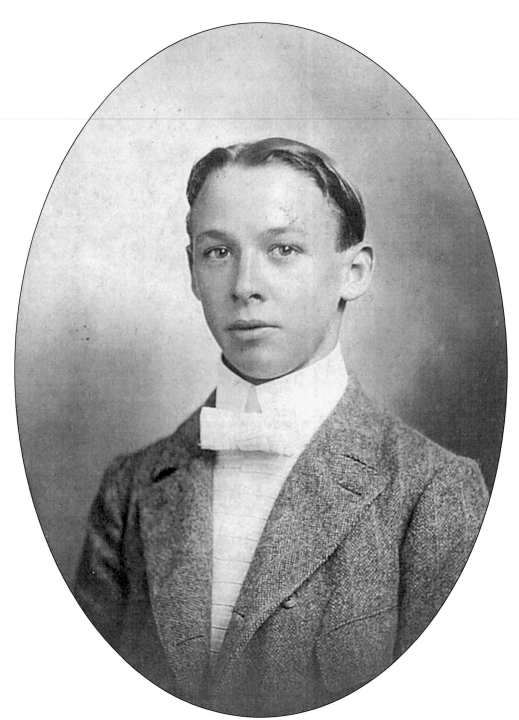

NORMAN MCNARY. The son of Charles, Norman's family resided for many years at Foulke Haven. He reminisced in later years that after the devastating freeze of 1886, when he was a boy, he could put his arms through the center of the ruined citrus trees, half of which were hollowed and blistered by the bonfires lit to protect them and the other half ruined from having frozen solid.

ARCH AND ANNA MCNARY.
Arch McNary, the older brother of Norman, married Anna Sterthaus. Her family lived in a small settlement called Germantown in the southern part of Ormond. These German settlers were noted for the excellent wines they bottled. The Sterthauses' Melrose Dairy was also a productive family venture for years. Sterthaus Drive, located just north of Three Chimneys, was named after this prominent family.

DIX HOUSE. Formerly known as Dix Hall, the old home has changed little throughout his life. It was named Dix after McNary's unmarried sisters-in-law who lived there. The second story remained a large room for many years, and it was used for social gatherings and political meetings. If walls could speak, these certainly would tell interesting tales of bygone days.

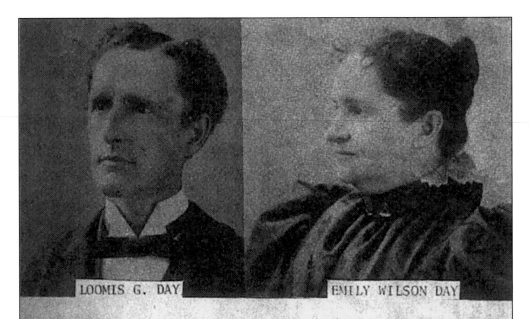

LOOMIS G. DAY EMILY WILSON DAY

Ormond's First Wedding

By Hazelle Fenty

On March 2, 1876, Miss Emily Wilson (daughter of one of the first three men to settle and name the New Britain Colony) and Loomis G. Day (son of Matthias Day who, in 1870, had laid out the settlement which later became named Daytona) were married in her home, the Colony House - but not without having to overcome a few handicaps.

Material had been ordered from Connecticut for the wedding dress. A few days prior to the nuptials, when it became evident that the material would not arrive, the women of the community began to "make do" as the saying went.

One contributed a dress of suitable fabric and the others began to work on it and soon the bride was perfectly fitted.

The rough, unfinished interior of the Colony House was converted into a thing of beauty as men and women worked together covering the bare chimney with white sheets and filling every nook and cranny with fragrant bittersweet orange blossoms and wild yellow jasmine vines.

A hoop skirt was covered with the same flowers and vines to become a huge wedding bell suspended from the ceiling rafters, under which the bridal couple stood for the ceremony.

Their beloved Rev. Pinkerton had gone to Kentucky for the summer so they had to search for another minister. They finally located Rev. Charles Sellick, a retired minister living in New Smyrna, 26 miles south, who agreed to come. The afternoon of the wedding, a tropical storm started.

The wind and rain were so fierce that many wondered if the minister, who had to come up by boat, would arrive - but he did and just in time to (Continued on page 9)

THE FIRST WEDDING. This is part of a reprinted article detailing an important event in our little community. Emily was the deputy postmistress at the time the couple met. The newspaper headline was from a later time because the wedding transpired before the town was Ormond.

JAMES CARNELL. Born in Leicester, England, Carnell was reared in New Britain, Connecticut, and became a mackerel fisherman. After an almost-fatal boating accident, he developed rheumatoid arthritis and moved here while still hobbled with crutches. Recovering in six weeks, Carnell later became postmaster and achieved other recognitions, including his selection as the grand exalted ruler of the Masonic Lodge. He was a businessman whose guava jelly production reached 55 tons a year. For many years he served on the city council.

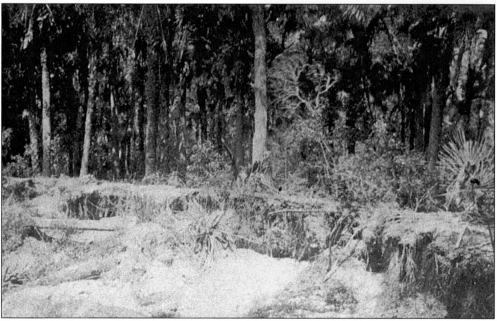

ORMOND SHELL MOUND. In April 1899, W.S. Blatchley, a naturalist, explored the Native American shell mound located on the west side of the Halifax River about 1 mile north of Granada Avenue. This mound had been used as a source of coquina shell for surfacing roads and sidewalks in the new Ormond. Blatchley was most interested in the varieties of marine and freshwater mollusks he found in the mound.

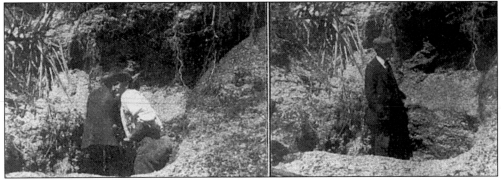

MOUND EXCAVATION. This excavation measured 1,136 feet in length and from 144 to 213 feet in width, about the size of five football fields! Originally, shells rose 10 feet above ground level and extended to a depth of 8 feet. The majority of shells were coquina clams, but there were over 28 other varieties of shells and mollusks, along with the bones of deer, wolves, porpoises, gophers, alligators, turtles, and sharks.

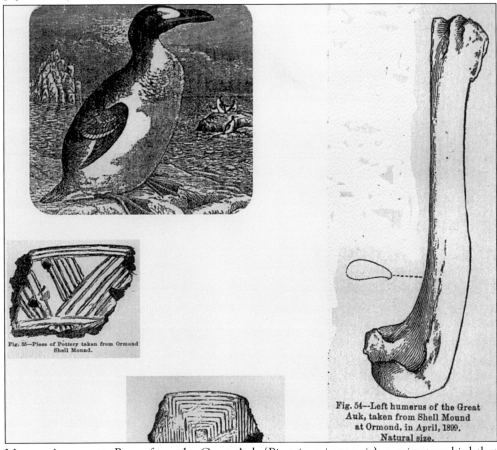

Fig. 55—Piece of Pottery taken from Ormond Shell Mound.

Fig. 54—Left humerus of the Great Auk, taken from Shell Mound at Ormond, in April, 1899. Natural size.

MOUND ARTIFACTS. Bones from the Great Auk (Pinguinus impennis), a migratory bird that became extinct in 1844 and swam from Iceland to nest on America's southern coast, were also found. Above left is the flightless bird, hunted for its flesh and oil, and to the right is its left humerus. Pot shards, as pictured, were among the findings. In 1902, Blatchley published a book of his discoveries titled *A Nature Wooing*.

Six

HOTEL ORMOND

John Anderson and Joseph Price, two pioneers of Ormond, along with Stephen Van Cullen White, a Wall Street broker, financier, and winter visitor, were the three men who built the 75-room Hotel Ormond in 1887. The hotel was located on the east side of the Halifax River on parcels of land owned by Anderson and donated by Charles Bostrom. Later, White helped finance the bridge across the Halifax River.

The opening of the hotel on January 1, 1888, was a memorable day for the fledgling Ormond village. James Ormond III, in his 80s, arrived from Atlanta. The hotel's season lasted through March. Dr. S.E. Fairchild and his sister were the first managers; later, Anderson and Price ran the hotel. During summer months, the two men managed hotels in the White Mountains of New Hampshire.

Henry Morrison Flagler, an 1870 partner of John D. Rockefeller in Standard Oil, purchased the structure in 1890 and enlarged it. In 1904, he built the Ormond Garage on the hotel property. The garage burned down in the 1970s. In 1903, Anderson and Price, Ransom Olds (the founder of Olds Motor Works) W.G. Morgan, and J.F. Hathaway sponsored the first automobile races on Ormond's beach. Later, world-famous race drivers gunned their cars south of Ormond toward Daytona, establishing world speed records.

Milton Pepper, an Ormond Beach businessman, purchased the Ormond Hotel for $2,010. It was placed on the National Register of Historic Places on July 11, 1980. After Mr. Pepper suffered financial difficulties, he received permission to demolish the beautiful edifice. Perhaps the saddest day in Ormond Beach was the day the 104-year-old hotel was demolished: May 26, 1992.

JOHN ANDERSON. An early pioneer from Portland, Maine, whose influence is still felt in Ormond Beach today, Anderson arrived in New Britain on February 26, 1876, at age 23. He and Samuel Dow bought, for $125, what was to become the Santa Lucia Plantation and the future home of the Ormond Hotel. Later, the men moved into a rough cabin they named Trapper's Lodge, which started Anderson's permanent imprint on Ormond.

JOSEPH PRICE. Price was John Anderson's friend and partner in ownership of the Hotel Ormond and other enterprises. Price lived in Hammock Home when they met. The two began a lifelong business relationship and an ongoing promotion of Ormond, which significantly contributed to attracting vast numbers of people and a variety of activities to our community. Both men died, only months apart, in 1911, having enjoyed lives filled with many completed visions.

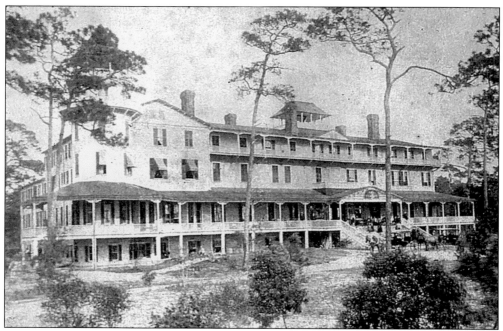

HOTEL ORMOND IN 1888. This photograph shows the hotel, originally painted white and later painted yellow by Henry Flagler, surrounded by pine trees. These trees were replaced by sabal palms to give the grounds a tropical atmosphere. The hotel's numerous windows provided picturesque views of the Halifax River and the mainland side of the peninsula. The hotel opened with 75 rooms, but later additions eventually increased the room number to 333.

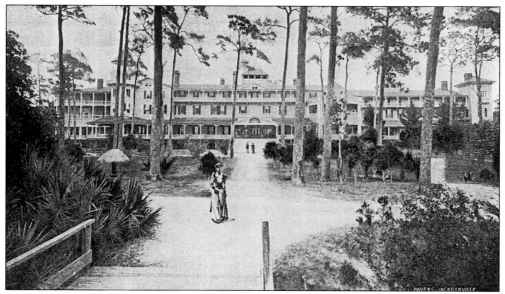

VIEW FROM THE WEST. An early broad-scoped view of the hotel with pines in place, this photograph shows an umbrella-shaded woman strolling to the pier. The dock extended into the Halifax, and it often had small watercraft tied to its side. Larger vessels frequently arrived bearing famous visitors. One such notable visitor was President Warren G. Harding (1921–1923), famous for supporting women's suffrage and the 19th Amendment.

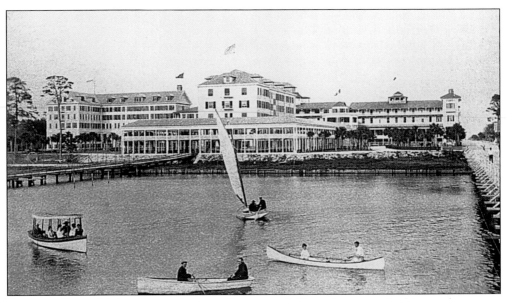

FROM THE RIVER. Various forms of river craft were available to the guests. In this popular picture we see some of them: two rowboats are manned, a small sailboat is attempting to catch a breeze, and a canopied touring boat sets out for a ride. The hotel dock is on the left, and the bridge lined with pedestrians is on the right.

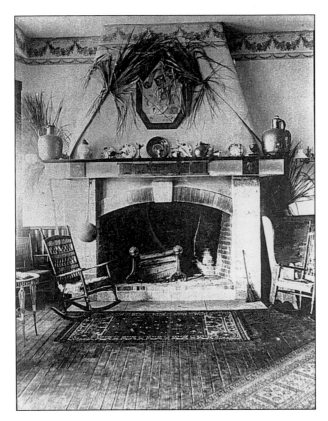

THE FIREPLACE. Another fascinating gathering spot at the hotel was around this imposing fireplace. Above the mantel loomed the colorful Ormond crest, here partially obscured by decorative palmetto fronds. This was a warm, cozy area on chilly days where guests gathered to play table games, such as checkers, cards, and chess, at card-tables drawn close to the fire. At other times people could read, chat, or exchange tales.

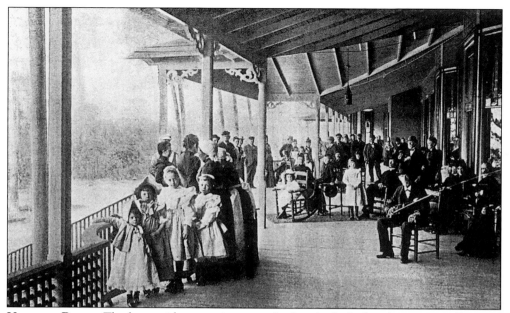

VERANDA PARTY. The long, wide, sweeping verandas for which the hotel was especially noted provided popular gathering spots and would usually be filled-to-overflowing with wintering guests. They would rock in the high-backed chairs, read, visit, and enjoy the lovely views and fresh air. Often entertainment would attract them from their rooms. Here we see a fiddler tuning up to play for the multi-aged gathering.

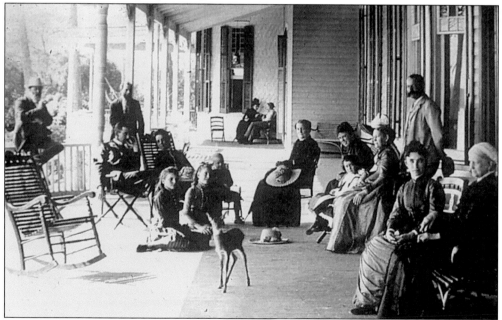

ANOTHER PORCH SCENE. Hotel guests admire this tiny fawn, which was probably brought in by a hunter. Unsteady on his feet and on an unfamiliar wooden floor, he pleads into the camera for help. The woman in the right foreground, resembling *Whistler's Mother*, is the famous author of the 1852 novel, *Uncle Tom's Cabin*, Harriet Beecher Stowe (1811–1896). She was probably visiting from her winter cottage in Mandarin, Florida, near Jacksonville.

71

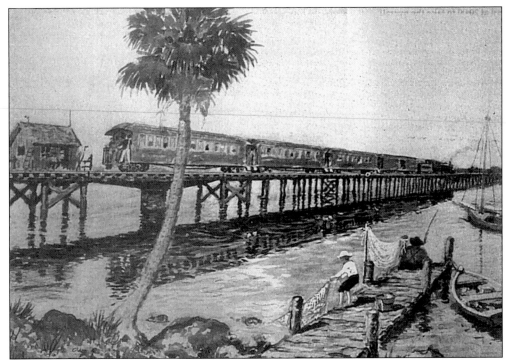

DELIVERING GUESTS. The Florida East Coast Railway's arrival in Ormond increased the ease of visitors coming to the area once Henry Flagler decided it would be profitable to extend his line south of St. Augustine. By bringing guests directly to the hotel by train, he facilitated their traveling. This picture is dated 1891, and it shows the train backing up across the causeway from the peninsula.

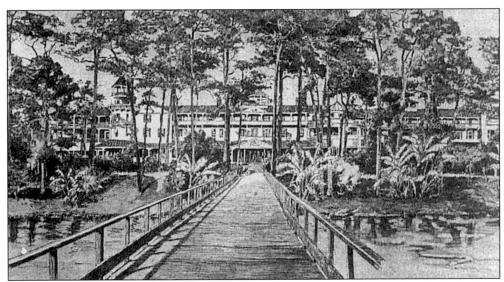

DOCKSIDE. The graceful, sprawling structure presented itself in all its splendor to anyone who strolled out onto the dock and turned to take in the glories of the hotel. This lovely scene is dated 1894 and shows off the tall pines and banana plants growing along the shore of the Halifax River.

72

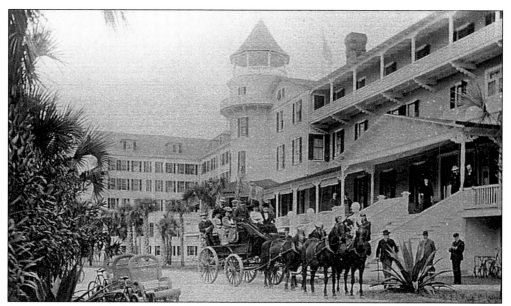

EARLY DAYS. A handsome Tally-ho coach filled with hotel guests is ready to start a drive along shell-paved roads or to the beach. With four horses in the lead, visitors were in for a special outing. An American flag often would be displayed along the side of a coach. Awaiting passengers, Afro-mobiles remain at the ready. The red-painted, conical-roofed cupola (today the centerpiece of Fortunato Park across John Anderson Drive) is atop the hotel.

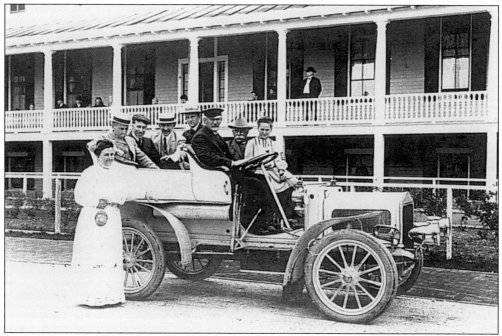

AUTOMOBILE OUTING. When automobiles came into prominent use many visitors chose this motorized form of transportation for sightseeing excursions. Identified are Mrs. Curie, John Anderson, Mr. Kearney, Joseph Price, "General" Sam Anderson (driver), and Ruth Anderson Carruthers. "General" was an honorary title that John Anderson's father was given.

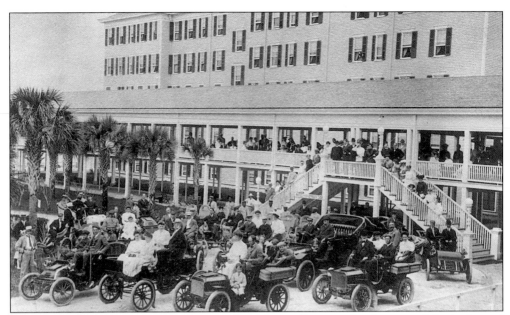

PARADE TIME. On display here we see an outstanding collection of early automobiles in front of the Hotel Ormond. This picture illustrates the long, graceful hotel entrance and broad veranda, both lined with the winter visitors. The location of the main entrance was changed at different periods as the hotel was enlarged. Its over 104 years of occupation provided worldwide attention to East Central Florida and the amenities it had to offer.

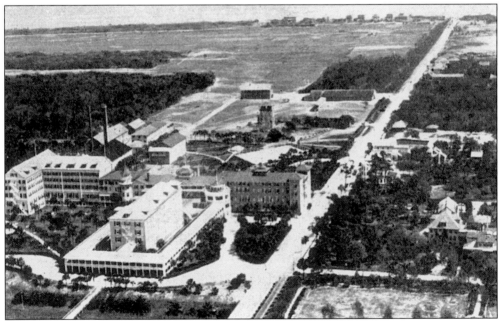

AERIAL VIEW. This photograph, looking east, shows the hotel and surroundings. South across Granada Avenue is The Casements. Toward the upper left of the picture, or northeast, is a section of the golf course. Famous golfers of their time, including Patty Berg, "Slammin' " Sammy Snead, Gene Saracen, and Babe Zaharias, often played Ormond's 18-hole fairways. In 1923, Ed Sullivan was its golf secretary.

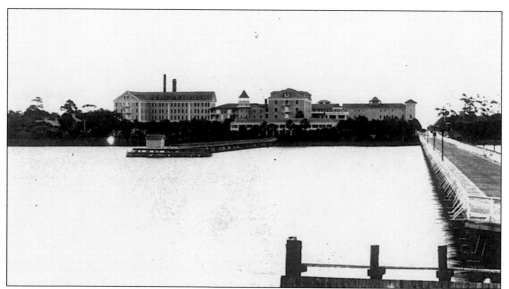

HOTEL ORMOND IN 1920. Connecting the peninsula with the mainland, this wooden causeway had a hand-cranked drawbridge for boats that plied the river carrying goods and passengers. The bridge clanked and clattered under the weight of wheeled vehicles or hoofed animals as they passed over—bridge sounds could be heard all over town. Pedestrians were charged 5 cents apiece. The Hotel Ormond is silhouetted in the background, highlighted by its smokestacks and Cupola.

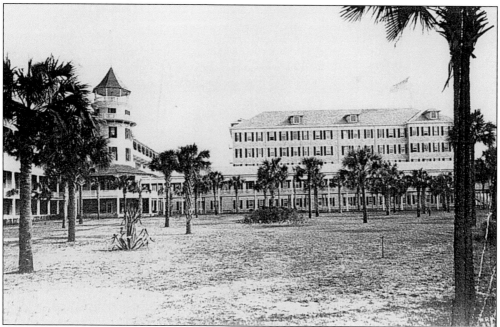

NORTH VIEW. This scene shows the north lawn after the removal of pine trees and the addition of cabbage palms. Many lawn parties and art exhibits took place here during the hotel season. As an example, Mr. Johnson, the hotel's manager, hosted a huge birthday event for his daughter. Included in the celebration were music by the hotel orchestra, ice cream, cake, and pony-cart rides. Many local children attended.

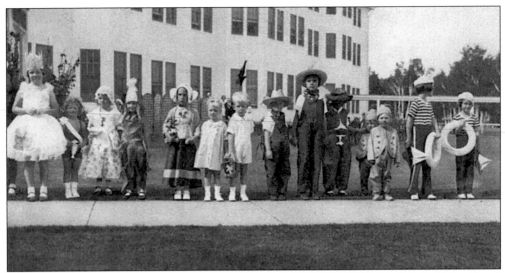

MAYPOLE DANCE. The winter tourist season often extended to the first weekend in May. Local residents sometimes provided entertainment for guests. On May Day, a Maypole Dance was held. Children, dressed in colorful costumes, regaled assembled onlookers with performances. Here they line up for a photo. The little tow-headed boy in the middle is John A. Bostrom's grandson, Don, an author of this book.

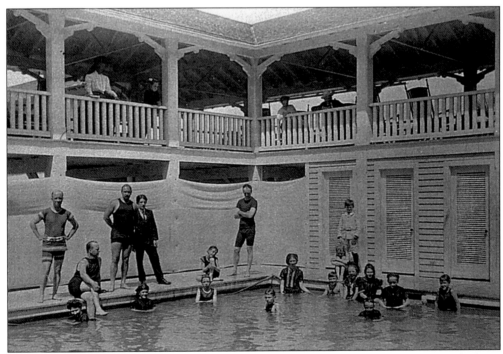

SWIMMING POOL. Piped in from the ocean, this salt-water pool was enjoyed by many bathers. Clad in garments that seem to cover too much by today's standards, the pleasure seekers, nonetheless, had great times. Local young people were invited to play in the water when guests left for the north and employees concentrated on closing the hotel for the summer months. Young Don, here again, is centered in the pool.

FRONT ENTRANCE DRIVE. A warm welcome entrance, both inviting and intriguing, awaited newcomers from their long tiresome journeys. The trip was worth the effort because the hotel provided every modern amenity to these weary pleasure seekers. Relieved of facing dreary winter months in the frozen north, guests were afforded the best that a luxury hotel had to offer.

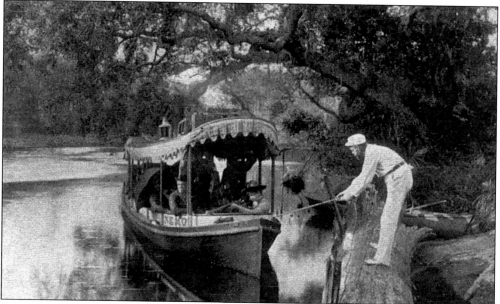

SIGHTSEEING ON THE TOMOKA. Vacationers relished waterway cruises protected by the colorful awnings. Arriving at the dock in the *Nemo* is a small group with Annie Oakley seated in the bow. Is she drawing a bead on one of the alligators in the Tomoka River? The sureshot celebrity certainly would have had many live targets in those days because the water teamed with wildlife.

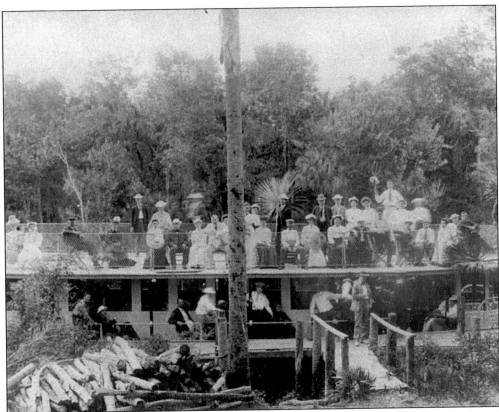

PRINCESS ISSENA. An outing on the river could be experienced on many different craft. One of the largest and most popular was the double-decked *Princess Issena.* Here guests are shown at Tomoka Landing, arriving for their luncheon picnic. The trip would have taken them past traces of rice fields, old cotton fields, and a grand variety of ancient bluffs, terrain, and vegetation. Exotic wildlife would captivate and enthrall them as it still does for visitors today.

ORMOND GARAGE. With the advent of the automobile age it became necessary to house and tend to these popular machines. After Henry Flagler purchased the hotel he had this long building constructed in 1904. It had a brick floor and "hosted" many famous cars. Known as "Gasoline Alley," it served an important role in the Birthplace of Speed. Its burning was mourned by all who had tales to tell of its heyday.

Seven

BIRTHPLACE OF SPEED

To the automobile owners and manufacturers staying at the Hotel Ormond in the opening years of the 20th century, the hard-packed white sands at the nearby beach appeared to be a natural proving ground for their gas- and steam-driven horseless carriages. After all, there were no obstacles on the beach, and they could drive for miles in a straight line.

They gave it a try in 1902, and the following year, the American Automobile Association sanctioned official speed runs on the beach sands. During the trials on March 26–28, 1903, Horace T. Thomas, driving Ransom E. Olds' "Pirate," set a record for cars in the under 1,000-pound class of 54.381 miles per hour.

Ormond Beach immediately became the Birthplace of Speed in Florida, if not in America. Owners and drivers flocked to the area to attempt to set new speed records. Fred Marriott, driving a Stanley Steamer, stunned the racing world on January 26, 1906, by setting a new record of 127.6 mph, thus bringing global attention to the Ormond-Daytona area.

Many notable racing events occurred in the course of the first 50 years of the 20th century on the sands at Ormond and Daytona, some of them tragic. Frank Lockhart survived a crash into the ocean, but later died when a tire blew. Lee Bible lost control of his Triplex and roared into a Pathe cameraman. Both died, but the film was saved and shown worldwide.

A need for a more controlled environment became evident, and a permanent track was constructed in nearby Daytona Beach. No longer was there racing on the beach, but the memory of those early cars and drivers will remain forever in the history of racing.

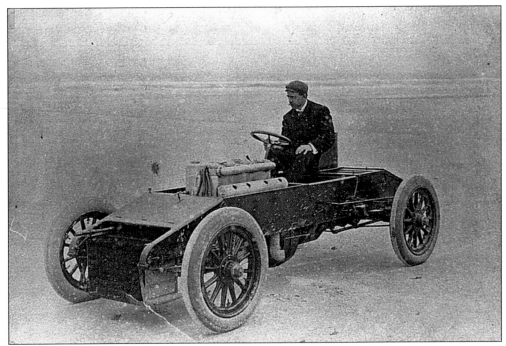

WINTON IN HIS BULLET #1. Alexander Winton sits behind the wheel of his "Bullet #1" racing car on the beach at Ormond in 1903. He set an American record that year of 57.49 miles per hour for heavy cars, over 2,000 pounds, in a 10-mile run.

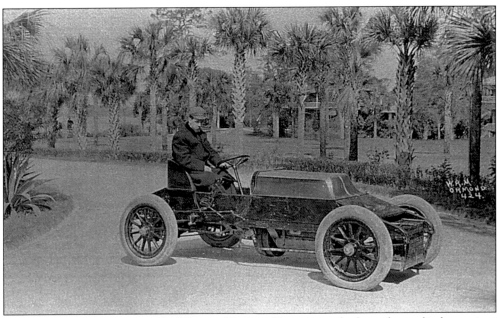

WINTON IN HIS BULLET #2. The Winton "Bullet #2" racing car had two four-cylinder engines bolted together, making it the first eight-cylinder (in line) automobile built in America. It weighed 2,150 pounds. In the 1904 "free for all," Barney Oldfield drove this Bullet #2 to a win over William K. Vanderbilt's 90-horsepower Mercedes.

BIG THREE OF EARLY RACING. These were the "Big Three" of the 1903 automobile races at Ormond: Ransom E. Olds, left, who had a car in the meet and gave financial support to the event; J.F. Hathaway, a promoter of beach racing, and "Senator" William J. Morgan, director and prime organizer of the race.

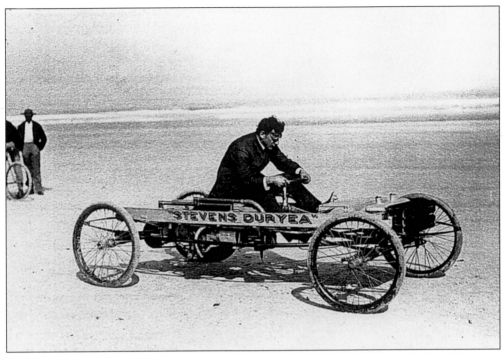

THE STEVENS-DURYEA "SPIDER." This race car weighed only 985 pounds. Driven by Otto Nestman in 1903, the Spider set American speed records for gasoline cars under 1,000 pounds in the 1-kilo, 1-mile, and 5-mile runs.

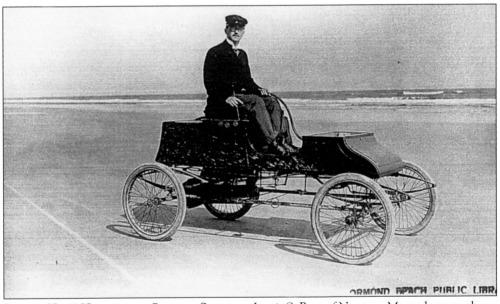

ORMOND BEACH PUBLIC LIBR.

ROSS IN HIS 6-HORSEPOWER STANLEY STEAMER. Lewis S. Ross of Newton, Massachusetts, drove his 6-horsepower Stanley Steamer in the 1904 races to a world's record for steam cars over the 1-mile course of 55.4 seconds. He later set the American kilometer record for steam cars in 34.4 seconds.

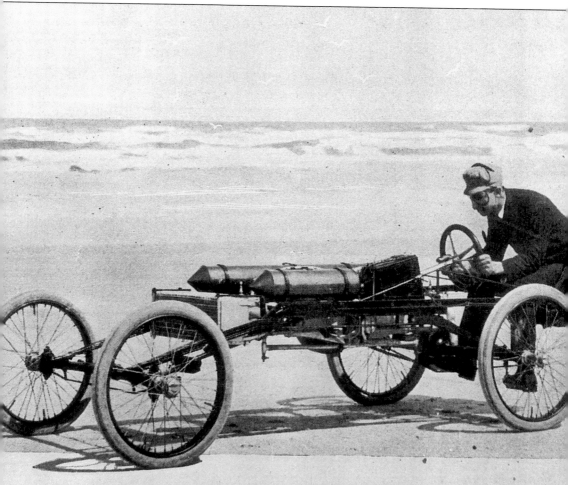

OLDS' "PIRATE," ORIGINAL BEACH RECORD MAKER

H.T. THOMAS IN THE "PIRATE." Ransom E. Olds built his "Pirate" for racing on the beach. His driver was H.T. Thomas, one of his company engineers. Thomas later became Olds's chief engineer when he formed his Reo Car Company. Thomas drove the Pirate to American records for light cars in the 1903's 1-kilo and 1-mile races.

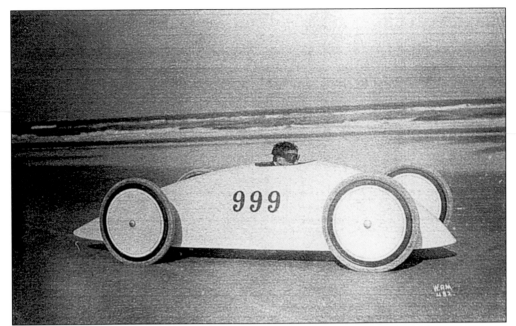

THE ELECTRIC-POWERED "TORPEDO KID." Walter C. Baker's "Torpedo Kid" was electric powered and streamlined for saving weight. In 1904, it set a world's record for electric cars in a 1-mile run of 59.406 miles per hour.

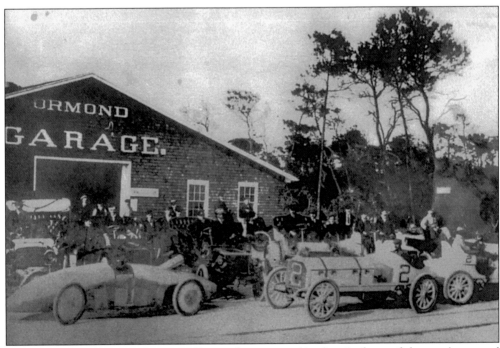

SPECTATORS AT ORMOND GARAGE. Cars and spectators lined up in front of the newly opened Ormond Garage in 1905. Seen in the foreground are an electric car, the Torpedo Kid, and a Mercedes with two engines—the Flying Dutchman, which set two world's records only to be disqualified because of its weight.

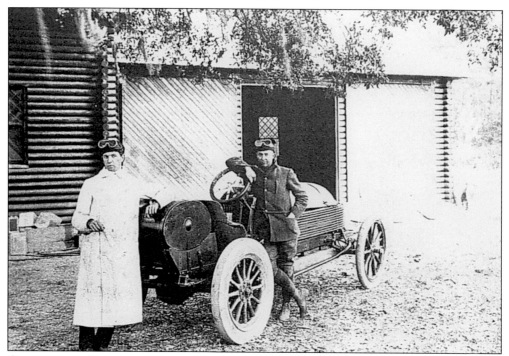

OWNER AND DRIVER OF THE NAPIER. Posing beside the Napier with "chauffeur" Arthur MacDonald is the owner of the automobile, S.E. Edge, an Englishman. The practice of the day was for the owner to have a chauffeur, and Edge chose MacDonald, one of Europe's leading race car drivers.

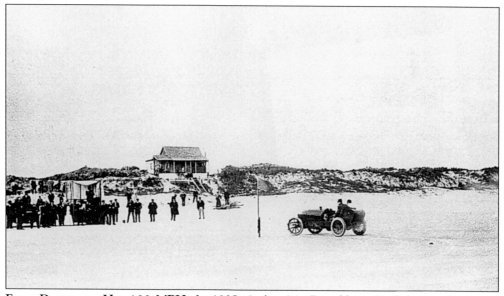

FIRST DRIVER TO HIT 100 MPH. In 1905, Arthur MacDonald, an Englishman, driving an English built/owned 90-horsepower Napier, was the first man to exceed 100 mph on American soil in a run of the measured mile on the beach. Fifteen minutes later, H.L. Bowden topped this in his "Flying Dutchman II," which had a Mercedes boat engine mated to the automobile engine. MacDonald also set world records in the 5-, 10-, and 20-mile races.

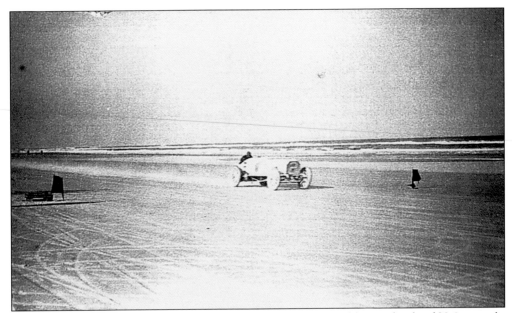

BOWDEN SETS A WORLD RECORD. H.B. Bowden, shown in his world-record mile of 32.8 seconds, spent nearly $50,000 putting together his Mercedes for the race. In 1905, that was a huge sum of money. After the race, the American Automobile Association declared Bowden's car disqualified because it exceeded the weight regulations, and they attempted to erase his world mark of 109.756 miles per hour.

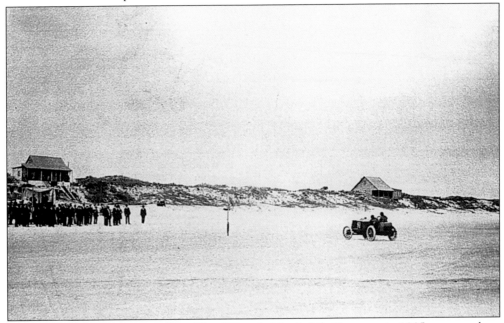

FLETCHER WINS VANDERBILT CUP. The 100-mile Vanderbilt Cup race in 1905 was won by a DeDietrich driven by H.W. Fletcher. He also won the next day's 50-mile race. The 100-mile race started at Bretton Inn and went to Ponce Inlet, a distance of some 16 miles, roaring between the pilings of the Main Street pier in both directions, for six laps. Fletcher set a world record of 1:18:24.

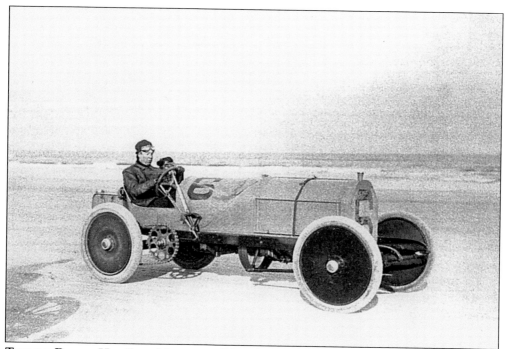

THOMAS DRIVES HIS OWN MERCEDES. Edward R. Thomas, a young millionaire from New York, took over the driving duties himself in the 1905 races, setting a temporary world mark in the 10-mile run in his 90-horsepower Mercedes. Three days later Arthur MacDonald erased his record.

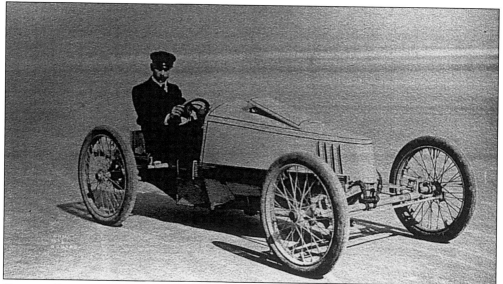

CHARLES SCHMIDT IN THE GRAY WOLF. The American-made Packard, a 24-horsepower Gray Wolf, was driven by Frenchman Charles Schmidt. In 1904, it set a world's record in both the 1-mile and 5-mile runs for gasoline-powered cars under 1,430 pounds. The Gray Wolf also set the American record for all weights in the 1-mile run.

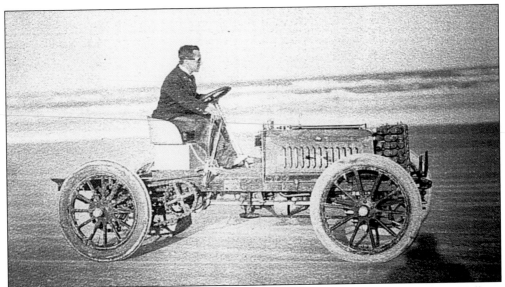

WON NO RACES, SET NO RECORDS. This 40-horsepower DeDietrich, driven by William Wallace, the vice president of the Boston Insurance Company, was the ultimate in automotive wind resistance with its blunt radiator, sharp corners, upright driver, and jutting parts. It won no races and set no records in early racing years.

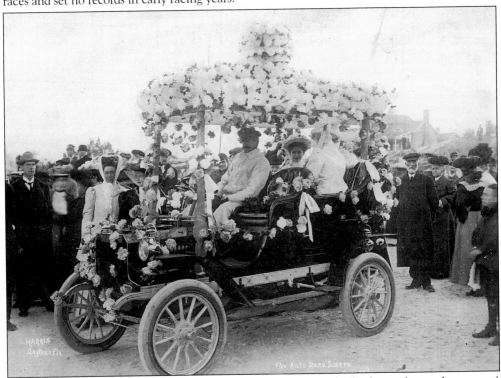

QUEEN OF THE 1906 RACES. Mary Simrall, 14, of Ormond (in the back seat facing the camera) was named queen of the 1906 Beach Races by the Florida East Coast Automobile Association. Seated beside her, in the white dress and hat, is Mrs. Joseph Price, Mary's chaperone and aunt. Ransom Olds provided the rose-festooned Reo touring car for the occasion.

Eight

CASEMENTS AND
JOHN D. ROCKEFELLER

In 1918, John Davison Rockefeller (July 8, 1840–May 23, 1937), the billionaire founder of the Standard Oil Company of Ohio, which in 1882 controlled 95 percent of the oil refining business in America and was later broken up into Esso, Exxon, Sohio, Mobil, Atlantic Richfield, and other companies, chose Ormond Beach to spend the winters because his physicians assured him of its healthy climate. Rockefeller purchased a three-story house on the corner of Granada and Riverside Drive. Named "The Casements" for its many casement windows, it fronted a splendid garden bordering the Halifax River. Other buildings on the property included a large garage, a water-softening plant, a greenhouse, and a nine-room superintendent's cottage.

Rockefeller died at his Ormond Beach home. Heirs sold The Casements to Miss Maud Van Woy for a "Junior College for Young Women." She closed the college in 1951, after which there were several owners of The Casements until the 1970s.

In the 1970s, vandals twice set fires, almost destroying the landmark. Purchased in 1973 for $500,000, the Ormond City Commission received a federal public grant of $449,000 for its restoration. The Ormond Beach Historical Trust, Inc. increased community consciousness through publicity and fund-raisers. The Casements Riverfront Gardens was dedicated in October 1976, having been restored by the Garden Club of Halifax County and the City of Ormond Beach. On a memorable Sunday, December 2, 1979, The Casements, now called The Ormond Beach Community Enrichment Center, was reopened. Displayed on the third floor are two exhibits, one of Boy Scout memorabilia and the other the Hungarian Collection. The Casements Guild, organized in 1979, acts as hostesses, guides, and operates a gift shop, proceeds of which go toward The Casements' furnishings.

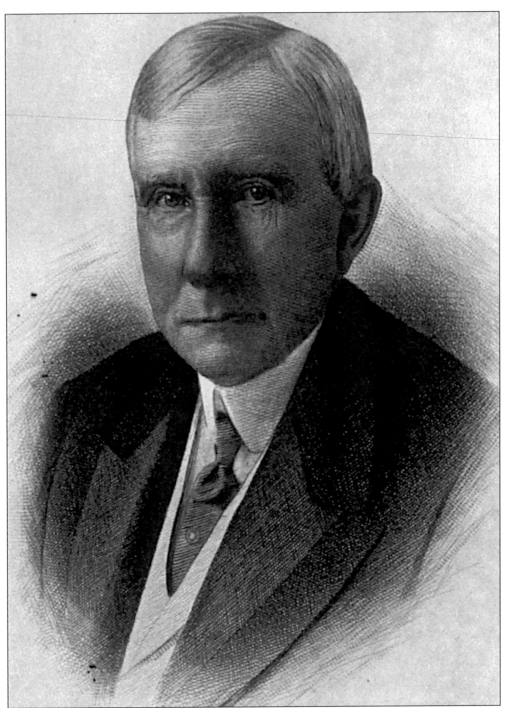

JOHN D. ROCKEFELLER. In his time and up to the present, most people in the United States, and a large part of the world, knew John D. Rockefeller was "the richest man in the world" at the turn of the century. After he made his fortune and retired to Ormond Beach, Rockefeller devoted his energy to giving away a large part of his fortune, and his benevolence mounted to nearly $600 million.

FAMOUS GUEST. One of Rockefeller's house guests was Will Rogers (1879–1935). After observing Rockefeller play a round of golf at the Hotel Ormond Golf Course, Rogers quipped, "I'm glad you won, Mr. Rockefeller. The last time you lost, the price of oil and gasoline went up." The popular humorist, columnist, and motion-picture actor provided the world with delightful observations and sharp criticisms of contemporary men in his homespun, yet humorous, manner.

THE CASEMENTS, 1935. Pictured here two years before Rockefeller's death at 97 is The Casements, his home on Riverside Drive. Having enclosed the porches, installed an elevator, and completed extensive renovations, which included adding the south wing for his quarters, Rockefeller preferred The Casements to his elegant homes in the North. This view was taken from the gardens west of the house, across the street.

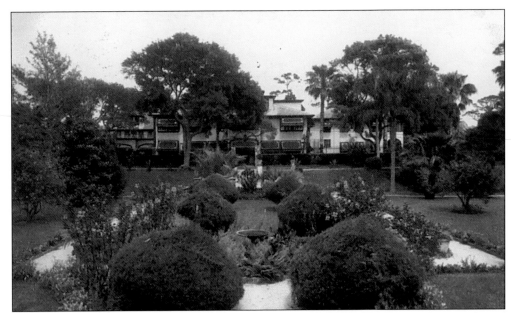

CASEMENTS GARDENS IN THE 1930s. Across the street from The Casements was its formal garden. It fronted the Halifax River/Intracoastal Waterway, a river busy with boating activities. Wildlife flourished and fed in it, as it does today. People used the river for transportation, and today, boaters can go all the way north or south on it. Rockefeller's desk faced this lovely scene, and he enjoyed his splendid view.

CHRISTMAS GIFTS. Rockefeller enjoyed a quiet life and attended few social functions as he aged, though "Neighbor John" did have famous Christmas parties. He often attended the Ormond Union Church and the annual fair held by the Village Improvement Association (VIA, now the Ormond Beach Woman's Club). He also had the unusual custom of giving new dimes to anyone he met. Here he is shown distributing presents to the grandchildren of John A. Bostrom, including Don Bostrom.

92

SINGING FOR JOHN D. ROCKEFELLER. Rockefeller was a well-respected member of the small Ormond community. Having had only one son, who had five sons, Rockefeller appreciated and enjoyed activities in the town, especially with its children. Here, a group of performers at a VIA Street Fair take pleasure in singing for him and others. Young Don Bostrom, donned in white shirt and tie, joined in the serenade.

ORMOND'S MAYOR AND FRIENDS. Although he had many famous friends visit him while he was "home" at The Casements, Neighbor John seemed to equally enjoy people of all walks of life. Here he is seen in his signature hat having a spirited conversation with Ormond's Mayor Rigby and two other gentlemen. Rockefeller's amiable persona put people at ease.

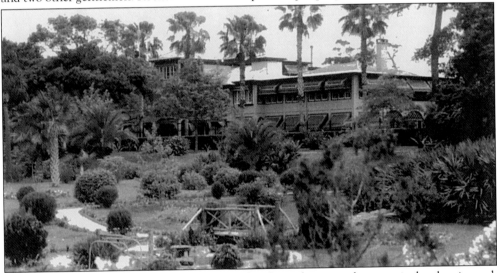

CASEMENTS SOUTH WING IN THE 1930s. The lovely gardens were kept meticulously trimmed, neat, and tidy. An enchanting wooden bridge and charming waterwheel added to its charm and ambiance. Here is a view of Rockefeller's main living quarters, added to the home overlooking the gardens and river beyond. The original part of the house was reserved for entertaining.

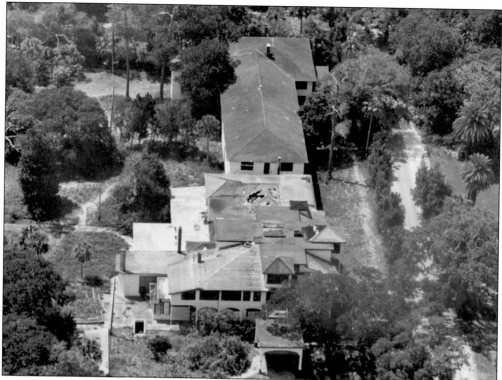

CASEMENTS AFTER FIRE. Twice burned, this historic mansion was photographed in 1972, showing some of the fire damage in the roof area from flames on the top floor that ruined two rooms and severely damaged others. Vandal-induced fires in 1974 practically destroyed any chances of the majestic home being restored to its former elegance. Fortunately, an outpouring of public support and the city's timely response finally rescued The Casements.

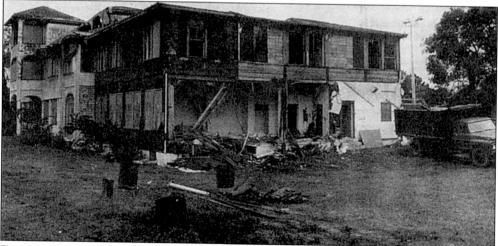

RESTORATION IN PROGRESS. Attention to detail and vigilance to period duplications highlighted The Casement's painstaking restoration. An 8,000-square-foot area, not part of the original layout, was omitted from its 21,497-square-foot size. The core of the building, that which surrounded the octagonal living room, was the main focus of restoration. Here is the south wing demolition. Presently, discussions are underway to rebuild this wing.

CASEMENTS ATRIUM. This is the first-floor atrium after extensive restoration. Today, it is filled with antiques, reminiscent of earlier, more formal times. Social functions are frequently held here. Docents are available for tours, and the gallery, formerly the dining room, is the location of changing exhibits. The Casements is not a sterile museum, but rather a beehive of activity, including a variety of classes, including computers, art, writing, ballet, and calligraphy.

THE CASEMENTS TODAY. After standing vacant in the 1970s and being gutted by fire, The Casements was placed on the National Register of Historic Places. The city purchased it in 1973 for $500,000, and a 1977 federal grant of $449,000 enabled restoration to begin. On October 1, 1979, this delightful period home was opened to the public. It serves as a cultural, literary, and civic center for the city.

Nine

ORMOND'S
AFRICAN AMERICANS

The first attempt at settling Ormond was built on the backs of African slaves and English indentured servants in 1765. In those early years before heavy equipment and machinery made clearing land and working easier, plantations in British-America required the exploitation of huge numbers of people. Sales records of that date from Charleston, South Carolina, along with records from the office of the governor of East Florida, attest to the purchase and shipment of slaves to the future Ormond. Once here, their work loads were horrendous at Richard Oswald's plantation, the Swamp Settlement, now known as Three Chimneys, according to letters written at that time. The work could never have been accomplished without these great efforts. One letter talks about the slaves hating their treatment so much that they rebelled against their first overseer, Samuel Huey, and drowned him.

Slavery has been a blemish on the face of civilization since recorded time; the world in 1764 was no different. However, since Abraham Lincoln led a divided nation to free the slaves and Martin Luther King and Rosa Parks paved the way for an end to discrimination, we have made slow but steady improvement in equality for all races.

Though records are scanty, we know that many slaves were blessed with the strength and perseverance to survive and prosper. Since the 1880s, we have well-documented records of black Americans living in our community and contributing to our growth and prosperity. Though many had humble jobs as laborers, caretakers, and nannies at first, most have improved their lives and educated their children to become proud and upstanding members of our society. Some of the pioneer black American families in Ormond are the Halls, Georges, Postells, and Colemans.

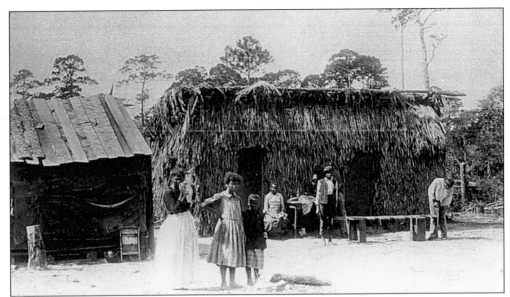

LIBERIA. In the period between the 1880s and 1900, the African-American community, located in the vicinity of Tomoka Road and White Street, was called "Liberia," after the first independent country established in Africa in 1821 by freed American slaves. After the Civil War, a group from the country of Liberia settled there. This picture shows one of the families in the area. In the background is housing that was typical. Another nearby settlement was Sudan.

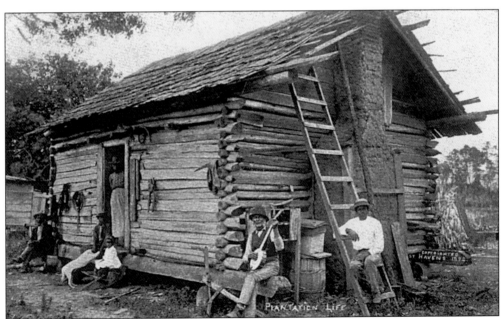

PLANTATION LIFE. Here is an African-American family in a typical log cabin of the time. The sign identifies the family as the Havens and the year as 1892. It is speculated that they were from one of the early plantation families. Note the fact that the home is raised above the ground. Most houses at the time were built this way for a variety of reasons, including allowing air to circulate and for preventing intrusions of local "critters."

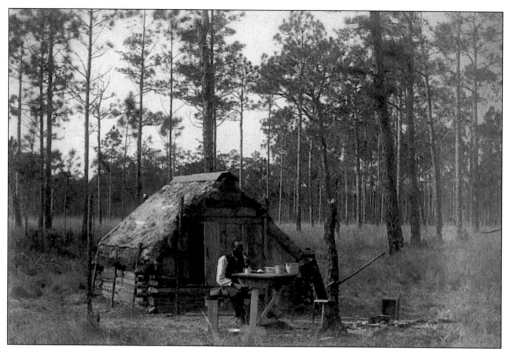

LONE JACK. This small cabin was located in the Tomoka area, and the man was probably one of the African Americans who participated in the active live oak trade of the period. Note his ax driven into the tree. For obvious reasons, he was referred to as "Lone Jack."

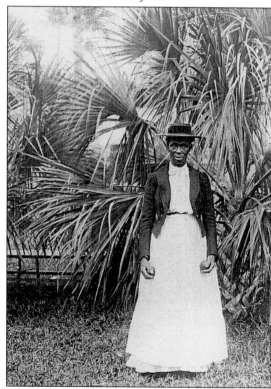

AUNT CHARLOTTE. This stately African-American woman framed by a background of a long-fingered cabbage palm was reputed to have been a former slave. She took great pleasure in smoking her pipe and worked as a maid and children's nurse at the Hotel Ormond.

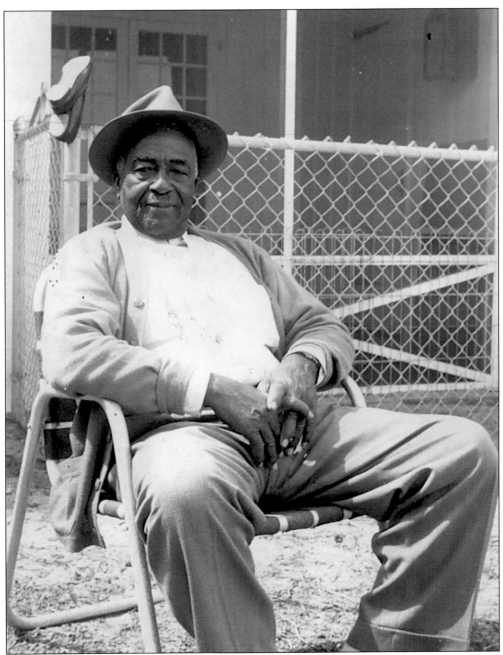

ESSIE RAMSEY. Born in 1880, Ramsey died in 1984. He was a distinguished citizen in the African-American community and worked as a gardener and caretaker at the Reynolds home on Halifax Drive. He was a deacon at the Saint John Missionary Baptist Church. Prior to his death, he was the oldest living member in the African-American community.

MABEL ROSE BAKER. This devoted member of the African-American community lived from 1893 to 1993. One of the first students to attend Bethune-Cookman College, Mabel Baker continued to be an advocate of higher education throughout her life. She helped plant many oak trees that grace the grounds of the college. In 1985, the City of Ormond Beach honored her as its oldest living citizen. Mabel belonged to the historical New Bethel African Methodist Episcopal Church.

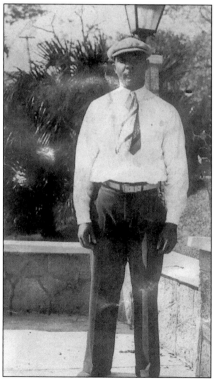

FRANK GEORGE SR. Frank George Sr. was born in 1895 and died in 1954. The George family is one of the most respected in the African-American community. Frank and his wife, Ethyl, spent most of their lives working at Bosarve for the Bostrom family. He is remembered fondly for all he taught young children. In his later years, Frank served as the night watchman at Rockefeller's Casements.

SHIRAS ESTATE. This view of Riverside Drive was the location of the Shiras Estate. George Shiras Sr. was a member of the United States Supreme Court, and his son was active in national politics in 1895. George Shiras III attained worldwide recognition as a wildlife photographer.

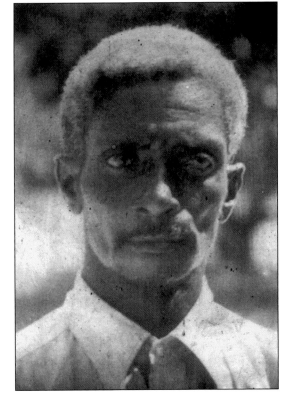

CHARLES GEORGE SR. This serious gentleman was the brother of Frank George Sr., and he lived from 1897 to 1954. Most of his life was spent working as a gardener and caretaker for the Shiras Estate on Riverside Drive. He had a rich voice and sang in the Saint John Missionary Baptist Church Choir. He is survived by one son and three daughters, all still living in the family home on South Yonge Street in 1999.

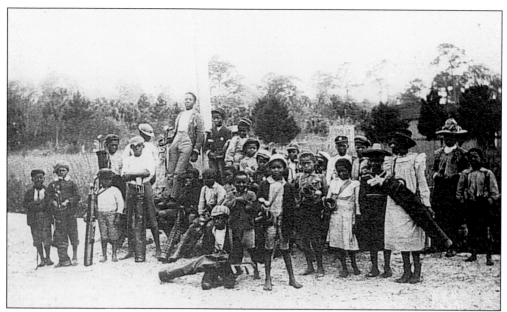

YOUNG CADDIES. These enterprising young children anxiously await their turns to be caddies at the Hotel Ormond Golf Course in the early 1900s. They were called by number, and it was a special treat to be selected by John D. Rockefeller. An amazing comparison is the small number of clubs people used in those days. No wonder golf carts are needed by so many today.

JOHN D. AND WALTER. As a youth, Walter Wolfe was a caddie at the Hotel Ormond Golf Club. He was a favorite of John D. Rockefeller and is shown here receiving one of the famous dimes from the courtly elderly gentleman. (Note Walter's fashionable plus-fours.)

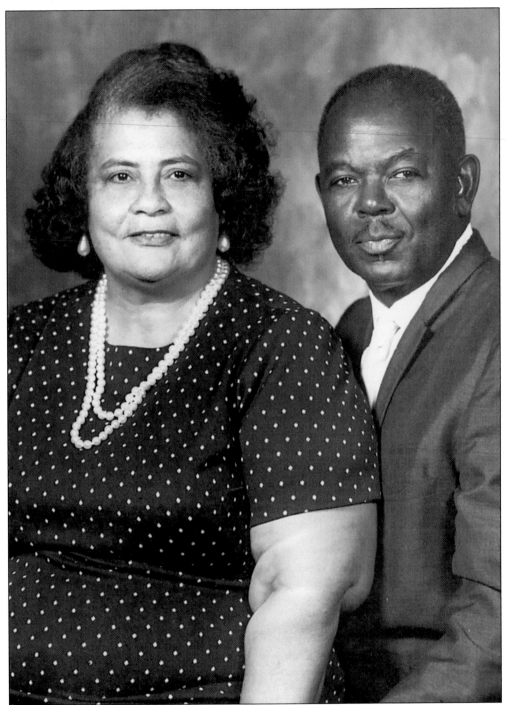

REVEREND AND MRS. WOLFE. Reverend Walter Wolfe was born in 1917 and is a devoted leader of his community. He and Bertha celebrated their 50th wedding anniversary on July 30, 1998. They have two sons, Reginald and Theodore. Walter was licensed to preach in 1967 and was ordained as a minister of the Saint John Missionary Baptist Church in 1970 by the Northeast Baptist Association.

OFFICER EDWARD ROGERS. This handsome gentleman has the distinction of being the first African American to serve in the Ormond Beach Police Department. He was with the department from 1926 to 1928.

OFFICER FRED POWERS. The son of Reverend and Mrs. A.C. Powers, Fred was born in 1925 and died in 1983. Fred attended Rigby Junior High and volunteered for the U.S. Navy. In 1952, he joined the Ormond Beach Police Department, from which he retired in 1972. He was the first officer to retire with 20 years of night duty service. Survivors include his wife, Dorothy, his son, and two daughters.

MINNIE WADE. Born on December 8, 1926, Minnie has spent her life serving the Ormond Beach community. She received several higher education degrees, three from Florida A&M University. She dedicated her professional life to teaching young children. Her volunteer and service affiliations are countless. Among other present activities, she is on the board of the Ormond Beach Historical Land Preservation and is an executive board member of the NAACP.

THELMA IRVIN. Thelma has lived in Ormond Beach since 1971, serving in the Volusia County School System as a reading specialist. Thelma has been active in many community services and, in 1998, was elected city commissioner for Zone 2, the first African American elected to the commission in Ormond Beach. She continues her commendable work, earning the respect of her constituents, fellow commissioners, and the citizens of Ormond Beach.

Ten

MID-20TH CENTURY AND TODAY

After Richard Oswald's attempt to purchase and settle Ormond between 1764 and 1776, nearly a century passed before the arrival of John Andrew Bostrom in 1868, when the first sustained settlement occurred. On April 22, 1880, the fledgling New Britain colony incorporated and changed its name to Ormond. Soon, railroads, bridges, automobiles, and a grand hotel changed the social and economic character of Ormond. More changes occurred as the autos and roads improved and sun-worshippers ventured farther south, followed by much of the citrus industry. Ormond's first century saw it grow to 14,000 residents by 1970. The next 30 years witnessed an explosion to 34,000, an astonishing 2.75 percent compound growth rate. Ormond annexed communities and became Ormond Beach in 1950. The city now has 350 employees, comprises 29 square miles, has a budget of $17.7 million, and a tax base of $1.6 billion with over $50 million added each year.

Ormond Beach today is far from just being the resort haven of yesterday as new companies and international markets are built by today's entrepreneurs. Ormond Beach has become a "City of Neighborhoods and Parks." It prides itself with a leisure service budget of $2.6 million. Our citizens enjoy quality time with abundant recreation in a network of 25 parks and complexes featuring big trees, clean waters for boating, swimming, and fishing, and a healthy family environment with lifelong learning opportunities. Ormond Beach is striving to maintain a balance between rapid commercial and industrial growth and the desire to maintain our historical heritage and casual atmosphere. The Ormond Main Street Association has developed an attractive streetscape program to control traffic and encourage downtown business growth. We have a proud rich history, and it is our goal to preserve that history for future generations.

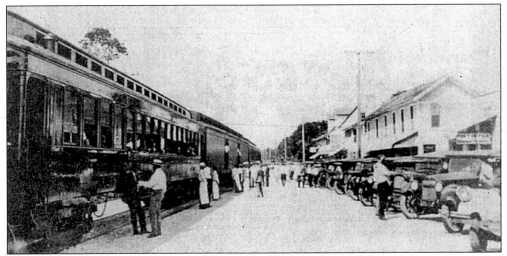

TRAIN STOPPING IN THE 1920S. This train, part of Flagler's Florida East Coast Railway, is shown stopped on West Granada in the 1920s. The train would deliver passengers to the south entrance of the Ormond Hotel. Some of the wealthy guests arrived in their own luxurious private railroad cars, which would be kept on a railroad siding on the mainland.

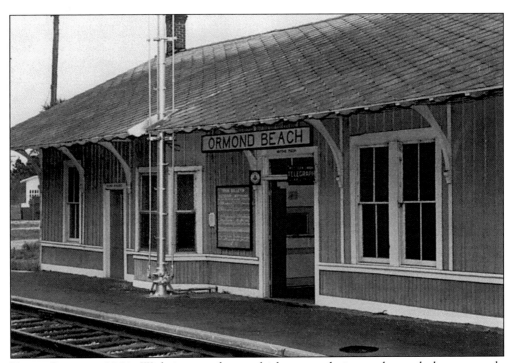

TRAIN STATION, 1961. With improved super highways and air travel, people began to rely less on train travel, and the number of passengers decreased significantly after World War II. Communities all over America no longer relied on depots for their journeys. Here is Ormond's deserted Florida East Coast Railway station in its waning days. Few people today have memories of a clickity-clack ride over a railroad track.

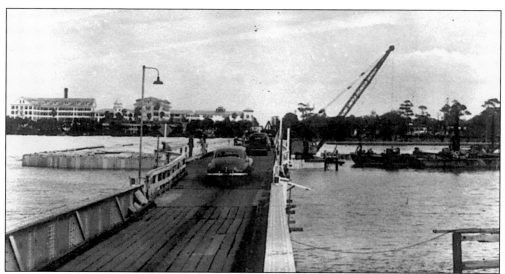

END OF WOODEN BRIDGE. John Andrew Bostrom, financed by Stephen Van Cullen White, built a wooden, one-lane toll bridge (5¢ per person) over the Halifax River in 1887. In later years, the bridge was widened and a manually operated drawbridge added. The rattling of the loose wooden planks could be heard all over Ormond as cars passed over it. This bridge was replaced in 1953.

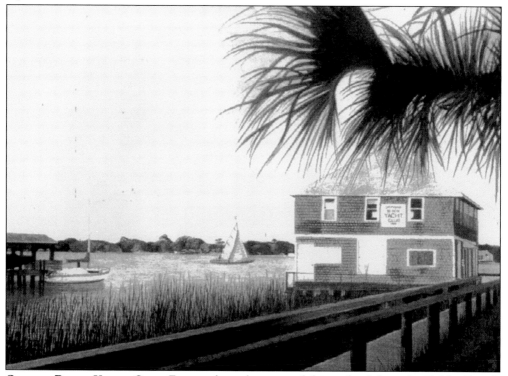

ORMOND BEACH YACHT CLUB. Forty early settlers erected this yacht club on the Halifax River's west bank, across from Lincoln Avenue on North Beach Street. Originally, it had a long dock where boys were taught sailing. Storms blew the dock away, never to be replaced. Being on the end of a right of way, it has never been listed on the city's tax rolls.

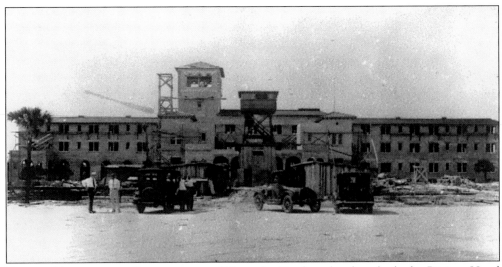

RIVIERA HOTEL UNDER CONSTRUCTION. When the Hardesty brothers built the Riviera Hotel as the centerpiece of their Rio Vista development in the 1920s, the area was part of the City of Ormond Beach. Later, unhappy with their water bills, they withdrew the hotel from the city. On a ridge line overlooking the Halifax River, the Riviera was intended as a rival for the Hotel Ormond.

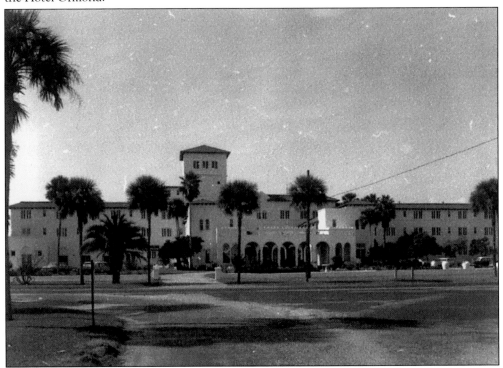

RIVIERA HOTEL. For many years this grand hotel, with its nearby golf course, was a popular hostelry. However, the building of large hotels and motels on the oceanfront gradually diminished its popularity and guest base. For many years it stood unused. Recently, it has been purchased, and it is being given a new life as an adult-living facility. It has been annexed into the City of Holly Hill.

WOMAN'S CLUB. Today, the members of the Ormond Beach Woman's Club still carry on the goal established in 1891: "Working together to make Ormond Beach a neat, beautiful and healthy place to live." Every member, past and present, has shared in these efforts. In 1951, the club established a separate department for young women called the VIettes, now the Ormond Beach Woman's Club Juniors.

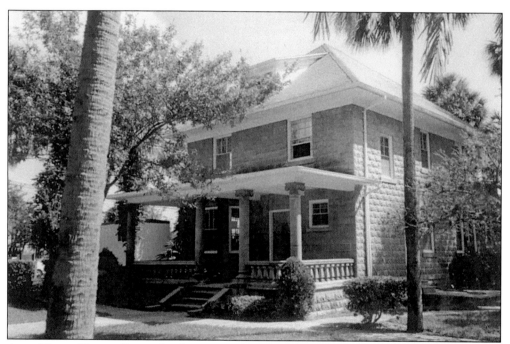

AMES HOUSE TODAY. Presently, the city is converting this historic house into offices for its city attorney. Originally built by a New York artist, William Barker, as a wedding gift for his son, the house is made of stone imported from Tennessee. Formerly called "The Stone House," it is now known as the Ames House, because it was later purchased by Blanche Butler Ames along with several other houses in the immediate vicinity.

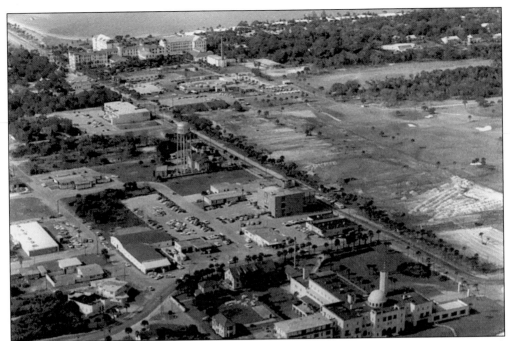

COQUINA HOTEL, 1960. Mr. and Mrs. Walter Bovard purchased the Coquina Hotel in 1945. Mrs. Bovard was operating the hotel when it had its final season in 1968. One of the reasons for its closing was the widening of A1A Highway. John Adriance held the record for the longest patronage of the hotel. He had been spending winters there since 1915.

ORMOND AIRPORT. The federal government reportedly purchased property and built an airfield to train pilots during World War II. Later, the federal government sold this property, which allowed its development as a private business that, today, has been greatly expanded.

CITY HALL, 1985. On the southwest corner of Corbin and South Beach Streets, a bank was built in 1925. It closed four years later during the Depression. The City of Ormond Beach bought it and converted it into city hall. The city added more space by purchasing several nearby buildings. After 60 years of use, the building was demolished in July 1989 and replaced by a modern structure.

CITY HALL TODAY. In November 1987, an $11.5 million bond issue was approved, and part of it was used for a new city hall, an enlarged auditorium, and a library. The city hall dedication was held on February 23, 1991. Most of the city's departments were finally housed under one roof; the city commission had an enlarged auditorium, and the parking area was greatly expanded.

MAYOR, COMMISSIONERS, AND DON BOSTROM. Ormond Beach's elected officials in August 1999 are, from left to right, Commissioners Jeff Boyle and Thelma Irvin, Mayor Dave Hood, Commissioners Frank Gillooly, and Carl Persis. The distinguished gentleman on the far right is Don Bostrom, grandson of John Andrew Bostrom.

BOSARVE, 1967. After the Bostrom family left Bosarve in 1934, Mrs. Henry Oltman purchased it and called it "San Souci." During World War II, the Women's Army Corps occupied it. Afterward, Gerald Althouse purchased the property and used it to house students from the private school at The Casements. Mrs. Jacqueline Kennedy leased it one winter. Later it was operated as a retirement home until 1967, when it was demolished.

ORMOND SUB-DIVIDES. As Ormond Beach grows into its second century, the urban area has become a city of neighborhoods familiar to most residents. Dozens of new, self-contained neighborhoods are springing up in the 29 square miles that comprise Ormond Beach today. Actual growth and annexation are increasing the population at nearly 3 percent, compounded, per year.

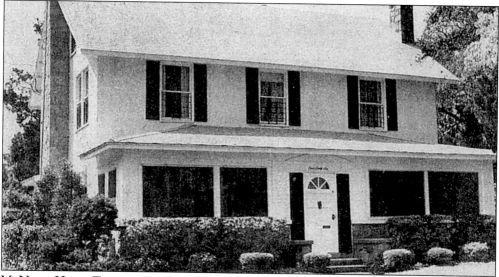

McNARY HOME TODAY. In today's world of instant obsolescence, it is refreshing indeed to touch base with our heritage. The McNary home, with only minor changes through the years, remains a haven of timeless tranquillity as Ormond Beach keeps up with the ever-changing demands of the future while guarding and preserving its past.

CHIEF TOMOKIE. Fred Dana Marsh, an internationally known sculptor, muralist, and architect, designed and executed this unique statue at Tomoka State Park. It depicts a fictional Native American story written by Marie Mann Boyd, the daughter of Florian Mann, the owner of early newspapers in Ormond and Daytona. Marsh spent seven years creating this work, and it was valued at $200,000 when dedicated on March 21, 1957. It was made from nearby red river clay.

EUROPA AND THE BULL. One of Dana Marsh's interests was American folk art. When he discovered this massive statue of Europa and the Bull in a dump heap, he salvaged it. In Greek mythology, Europa was a Phoenician princess abducted by Zeus, who had assumed the form of a white bull. Marsh purchased Europa from Barnum and Bailey in the 1920s, repaired it, and erected it on the west lawn of his home.

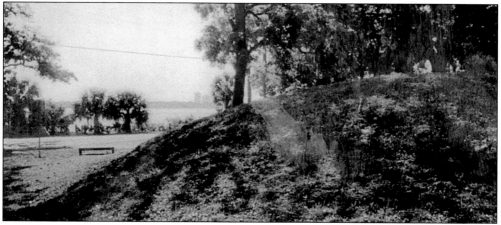

INDIAN MOUND. This large earthen mound was erected by the Timucuan Indians about 2,000 years ago for their dead. The city acquired the property on Mound Avenue and South Beach Street after stopping a developer's bulldozer from leveling it. A portion of the mound was excavated by the Daytona Beach Museum of Arts and Sciences. At the insistence of Native Americans, the bones and artifacts were later re-interred with appropriate ceremonies.

THE BATTLESHIP. In the early 1920s, Dana Marsh erected one of the most controversial houses on the sand dunes. Because of its streamlined nautical appearance, local residents gave it the nickname, "The Battleship." On the back lawn stood a monumental white statue of "Europa and the Bull," which frequently caused passers-by to gasp in shock. The house was demolished in the late 1990s.

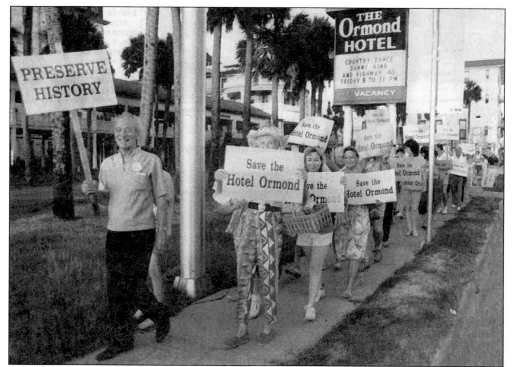

Save the Hotel! As rumors of razing the legendary landmark hotel were raised, the Historical Landmark Preservation Board, or HOPE (Hotel Ormond Preservation Enterprise), and other civic groups protested. Rekindled efforts and the public's hope of saving this priceless landmark from eminent demise grew. But it was to no avail. After much publicity, including protest marches, the wrecking ball proved victorious, and 104 years of grandeur became a memory.

Present Cupola and Ormond Heritage Condominium. When the Hotel Ormond opened it had a red-capped, white cupola, which stands today in Fortunato Park. Named after a longtime mayor/city commissioner, the riverside park fronts the Ormond Heritage Condominiums built on the hotel grounds. Due to efforts of the Ormond Beach Historical Trust, then City Commissioner Evelyn Lynn, financial aid from Milton Pepper, Audra Hurst, and others, the trust restored the cupola as the park's centerpiece.

119

ROWALLAN. This Southern-style 27-room home was built in 1913 of heart of cypress by Alexander Lindsay as a winter cottage. He called it Rowallan after his personal train car, which he and his family would travel to Ormond in for the season. Both were named after castle ruins near his boyhood Scottish home. Its third owner, Eileen Butts, changed its name to Lisnaroe, which is Celtic for "by the water." She was a multi-faceted woman who included horticulture as one of her many interests. Harvard University's Gray Herbarium lists 3,000 Florida wild flower specimens in her name. She was also recognized by the Florida Senate for her many achievements for service to her community and her historic preservation accomplishments. After her death in 1991 the house stood vacant until Mark Ascik bought it as a surprise 1996 Christmas present for his wife, Missy. Missy has lovingly restored it with extensive renovations and renamed it Rowallan, as it is listed on the National Register of Historic Places.

CAPO. Owned by Mark Ascik, CAPO is a manufacturer of sunglasses and has achieved a 10 percent share of the national market. CAPO has about 311 employees and manufactures its product from a complex of buildings at the Ormond Beach Airport Business Park. CAPO is one of dozens of new companies located in Ormond Beach.

FLORIDA PRODUCTION ENGINEERING (FPE). FPE employs about 140 people at a large facility located in the Ormond Beach Airport Business Park. FPE manufactures a number of products, including plastic components for the automobile industry, such as dashboard covers for air bags, hub cabs, and wheel covers.

SUNRISE AVIATION. Hector Lo (pilot), Learie Barclay (student-pilot from Guyana), and Greg Schamaun (director of operations) stand next to one of their fleet of ten planes at Sunrise Aviation. With 20 employees and an expanding business, Sunrise is making a name for itself in the training of pilots and the operation of a charter business. The former World War II airfield has been greatly expanded in recent years.

HAWAIIAN TROPIC. Owner and founder Ron Rice took his idea for a sun lotion and named it Hawaiian Tropic. On July 16, 1969—the same day the United States launched the first moon mission—Rice sold his first bottle. The worldwide company now employs 2,000 people. The 240,000-square-foot facilities here in Ormond Beach employ 350 people over three shifts a day and ships 530 trailer-loads of sun-care products each year.

RON RICE, PRESIDENT, AND EXECUTIVE BOARD. From left to right are Larry Adams (vice president, legal), Ron Rice (owner and founder), Jack Surrette (vice president, marketing), and Bill Jennings (vice president, finance).

PERFORMING ARTS CENTER. Standing before the Ormond Beach Performing Arts center are, from left to right, David Abee (recreation manager), Sylvia Frost (office manager), and Alan Burton (director, leisure services). This team of people supervises 25 parks and complexes, offers programs from music, singing, and art to languages, bridge, billiards, computers, dance, carving, plus a full sports program for all ages. There is something here for everyone.

ORMOND MEMORIAL ART MUSEUM (OMAM). In 1946, OMAM was founded to house paintings of Malcolm Fraser and to honor World War II veterans. Nestled in a 4-acre botanical garden that boasts exotic plans indigenous to Florida, with nature paths, ponds, and a gazebo, the museum is available for a variety of activities. OMAM currently offers 9 to 12 exhibits per year, showcasing regional artists and children's artwork. Pictured, from left to right, are Ann Burt (director), Jeanne Malloy (special projects), and Vanessa Elliott (administrative coordinator).

BILLY'S TAP ROOM AND GRILL. "Monk" and Jackie Noell, owners of the historic tearoom known as Billy's Tap Room and Grill, are proud of Ormond Beach's oldest restaurant. Over the past 77 years, Billy's has seen slot machines, 5¢ beer, and members of the Women's Army Corps, or WACS, in numbers during World War II. The Noells maintain the caring and homespun atmosphere in their award-winning establishment with its flavor of an English pub and featuring a bird's-eye maple bar and high-backed booths.

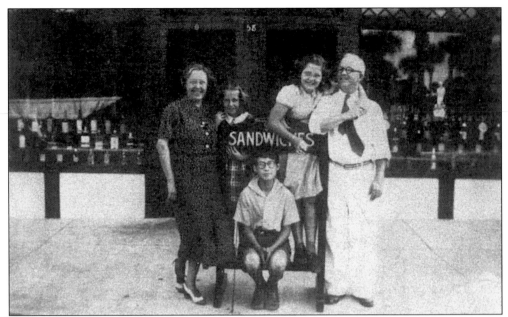

BILLY MACDONALD AND FAMILY. The family ran Billy's Tap Room for 63 years until they retired in 1985.

MACDONALD HOUSE. Members of the Ormond Beach Historical Trust are pictured, from left to right, Ceylon Barclay (sitting on stairs), Shirley Warner, Laretta Garland, Don Bostrom, Jane Robinson, Gordon Kipp, and Alice Strickland (in the rocking chair). The MacDonald House is a Queen Anne–style home built in the 1890s that now houses the Trust as well as other city organizations. It is named for the MacDonald family, who bought it in 1939 and who owned nearby Billy's Tap Room on East Granada.

126

JULIAN'S. Julian C. Lopez Sr. has been serving great food to Ormond Beach residents for 44 years. He opened his family-operated Julian's in 1967. This 5,000-square-foot building seats nearly 300 customers and employs 80 people. Dinner is served evenings, from 4 to 10 p.m., and the "restaurant never closes," says his daughter. "Well, almost. We closed for a hurricane once when I was a kid."

ORMOND FUNERAL HOME. This business is owned and operated by the local Lohman family, and Lowell and Nancy Lohman are third-generation funeral home and cemetery professionals. Their new funeral home incorporates Ormond Beach history in its design, using original windows from The Casements and other historical artifacts to grace its halls. Well-landscaped outside and elegant inside, the Lohmans used original artwork of historic landmarks painted by local artists to adorn the building.

. . . BIRDS! Visitors continue to flock to Ormond Beach to enjoy its sun, sand, surf, and satisfying climate.

THE FUTURE MEETS THE PAST. Jessie Reeds, Jeffrey Geiger, Samantha Lenhart, Kali Austin, Stephen Morgan, and Joshua Olson (eating his homework) are listening to Ceylon Barclay, the president of the Ormond Beach Historical Trust, explain how a rum distillery operated. Earlier that morning, these students of Ormond Elementary School had seen slides of Barclay's Grenada West Indies rum distillery in operation. The part they are looking at is the four fireboxes that comprise the boiling facility, where sugarcane juice was processed first.

128